ISBN 1-86154-247-X

STICK 'EM UP
MIKE DORRIAN / LIZ FARRELLY /
DAVID RECCHIA

LOCATION PHOTOGRAPHY
BLOTCHWOMAN / JOHAN BOER / DAVE /
GRAHAM DEWS / DMOTE / MIKE DORRIAN /
EROSIE / LIZ FARRELLY / FLIQ / GASR /
JOOST VAN DER HEIJDEN / RICHARD
HENNINGS / JEROEN JONGELEEN /
MIKE DEL MARMOL / MATTHEW MCCARTHY /
AMANDA MCPHERSON / PINKY / DAVID
RECCHIA / TOFER / GREGG VIROSTEK

SPECIAL THANKS TO
CHLOE ERLAM / GREGG VIROSTEK

FIRST PUBLISHED IN 2002 BY
BOOTH-CLIBBORN EDITIONS
12 PERCY STREET
LONDON W1T 1DW
UK

WWW.BOOTH-CLIBBORN.COM

© INTERNOS BOOKS LIMITED 2002

IF YOU HAVE ANY QUESTIONS CONTACT
LIZ FARRELLY ON EFARRELLY@HOTMAIL.COM

ACAMONCHI FANZINE
WWW.ACOMONCHI.COM
AKAYISM
WWW.AKAYISM.ORG
ANTIPUB
WWW.ANTIPUB.NET
BETAMAXXX
WWW.BETAMAXXX.COM
BILLBOARDING LIBERATION ACTIONS
WWW.BILLBOARDINGLIBERATION.ORG
JON BURGERMAN
WWW.JONBURGERMAN.COM
DUO
WWW.DUO-UK.COM
EL TONO STREET ART GALLERY
WWW.ELTONO.COM
ETRON
WWW.SHITTYPLANET.COM
INFLUENZA
HTTP://FLU01.COM
MYSTERIOUS AL
WWW.MYSTERIOUSAL.COM
RANDOM VON NOTHAUS
WWW.BUFFMONSTER.COM
SEVEN NINE
WWW.SEVEN-NINE.NET
STICKERNATION
WWW.STICKERNATION.NET
STICKIT SITE FOR STICKER FREAKS
WWW.STICKIT.NL

THANKS TO
DAVE KINSEY / KYLIE ABBOT / TOFER /
GARRET CHOW / EROSIE / DOM MURPHY /
RABBIT BOY / JON BARLOW / JOHAN BOER /
DAVE THE CHIMP / RANDOM VON NOTHAUS /
VENTURE 3 / CARL ISON / MAYA HAYUK /
ANDY SARGENT / DMOTE / LEE FRAMER /
JOOST VAN DER HEIJDEN / DAVE / ZEEL /
HOLD NO HOSTAGE / GASR / ACAMONCHI /
ETRON / ED MATTHEWS / SALLY HEMS /
JEROEN JONGELEEN / ALAN CAVANAGH /
JON BURGERMAN / ROY VALK / MAGMA /
ANDREW MCGOVERN / CRAIG METZGER /
HUNTERGATHERER / MATTHEW MCCARTHY /
PHIL ASHCROFT / JAKE STEEL / AKAYISM /
BLOTCHWOMAN / PINKY / BETAMAXXX /
JAMES LEE DUFFY / ZIME / PHET 15 /
RICHARD HENNINGS / FLIQ / PUZLE /
GRAHAM DEWS / DSKYZ / WILL BARRAS /
MYSTERIOUS AL / AMANDA WARING /
DWAYNE BELL / FISHBURN HEDGES /
MIAMI CREW / SEBASTIANO PIZZUTO /
SARAH RAMSEY / SPACE3 / LEE CURTIS /
JIM ALABASTER / EINE / MARK PAWSON /
NEASDEN CONTROL CENTRE / ADAMS /
ROB AT ALIFE / APRIL WILLIAMS / DUO /
RYAN MCGINNESS / CHRIS LAW / OBEY /
RIC BLACKSHAW / SOL CREW / BUMP

THE INFORMATION IN THIS BOOK IS BASED ON
MATERIALS SUPPLIED TO INTERNOS BOOKS
LIMITED BY THE ENTRANTS. WHILE EVERY
EFFORT HAS BEEN MADE TO ENSURE ITS
ACCURACY, INTERNOS BOOKS LIMITED DOES
NOT UNDER ANY CIRCUMSTANCES ACCEPT
RESPONSIBILITY FOR ANY ERRORS OR
OMISSIONS.

A CATALOGUING-IN-PUBLICATION RECORD
FOR THIS BOOK IS AVAILABLE FROM THE
PUBLISHER.

PRINTED IN ITALY

APRIL WILLIAMS
BRIGHTON
2001

SLAM CITY SKATES
LONDON
2002

VENTURE 3
LONDON
2001

AN ENVIRONMENTAL ARTIST POINTS OUT
THE IRONY OF POSTING ANY MESSAGE
IN THE PUBLIC DOMAIN.

SO MANY SKATE COMPANIES, SO LITTLE
SPACE ON YOUR BOARD.

A REBRANDING CAMPAIGN, RUN FOR
THE GERMAN COMPANY ISH, INCLUDED
HANDING OUT STICKERS SO THAT STAFF
COULD PERSONALISE COMPANY PREMISES,
AND PROMOTE A SENSE OF OWNERSHIP.

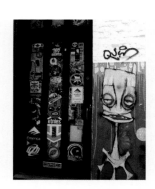

When pointing cameras in lots of unlikely
locations, while collating images for Scrawl
and Scrawl Too, we began noticing a new
star in town. You could say that stickers are
the new flyers, and that throw-ups and tags
have been superceded by these instant,
mini masterpieces.

In a weird déjà vu of an earlier era, and
hand in hand with the resurgence of graf
on the streets in the 1990s, arrests began
to hit the headlines, as graf-busting patrols
proliferated. Sadly, the big guys haven't yet
realised that painted streets often improve
the quality of urban environments. Inspired
perhaps by a fever for collecting logo
decals from skate companies, and the
mumbling mysteries generated by savvy
viral marketing campaigns, as well as art
activists and their cheeky additions to
billboards, a new generation of writers,
artists and designers got smart and
switched-on to stickers.

Why? Because speed=stealth, and the
convenience of "here's one I made earlier"
is preferable to being collared during the
lengthy and messy spray-paint experience.
Plus, with a pocketful of these little
wonders anyone can achieve maximum,
crack'n'peel, street-level coverage, while
adding another glossy, top-notch layer to
the visual noise of our urban environment.

And with so many people at it, you can
bet the mixture of styles, obsessions and
attitudes is intense. Among the cute and
cuddly characters, you'll also find dark
images of destruction and bold typographic
intrusions by the logo-makers of tomorrow.

F*CK
LONDON
2002

AN EXAMPLE OF BRAND SUBVERSION.

THINK!
NEW YORK
2001

THIS WAS FOUND PLASTERED OVER
AN AD IN THE SUBWAY.

AKAYISM & ADAMS
GUILTY GUILTY ZINE
STOCKHOLM
2002

STICKER ZINE FEATURING A POSSE OF
AVID ARTISTS AND LOTS OF FREEBIES.

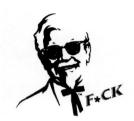

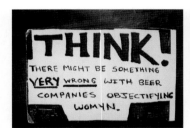

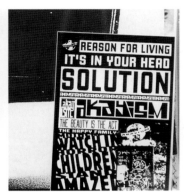

Similarly, the techniques for realising
these dreams are totally diverse, thanks
to the current collision of computer
technologies with the resurgence of mark
making. Take your pick. Whether they're
100% hand-rendered and wheat-pasted
into place; designed on a Mac and
pumped out of a newly affordable colour
printer; an artistic alteration of those
readily available, self-adhesive mail/postal
forms; or art-worked and printed Pronta
at Kinko's, stickers are the versatile,
high-profile new collectible, the most
on-it ephemera of the 21st century.
There's even zines dedicated to all of this...

Globe-trotting has also been a crucial
factor in the hatching of this phenomenon.
While compiling Stick 'em up, all three
authors, Mike Dorrian, David Recchia and
myself, Liz Farrelly, (aided by my trusty
companion Gregg Virostek), racked-up a
pile of air-miles on our search for precious,
rare stuff around the world. From Reykjavik
to Melbourne, San Francisco to Tokyo, the
amazing truth is that, undetectable as they
are in your luggage, stickers are enabling
artists to get-up all over. Spotting the same
little lovelies in Stockholm and Berlin, or in
London, New York, Paris and Manchester
goes to show that, have art, will travel.

DOM MURPHY/TAKTAK
STICKERNATION.NET
LONDON
2001

SANG 9
PARIS
2002

BUMP
LONDON
2001

OBEY
LOS ANGELES
2001

MARK PAWSON
LONDON
2001

THE SEMINAL PORTAL.

SOME FINE EXAMPLES OF AFFORDABLE
AND TRANSPORTABLE ART WORK BY
STREET AND DADA INSPIRED ARTISTS.

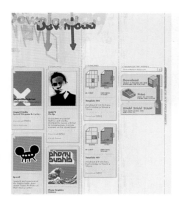

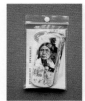

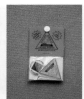

Of course then there's the ultimate techno advantage that stickers have over all other forms of ephemera...The fact is that you can log on to an artist's site, or the seminal hub at www.stickernation.net, download a bunch of favoured stickers, print them out and wack them all over your own home town, or wherever you happen to land. Maximising coverage in such a way, thanks to a willing posse of fans, is a very new idea indeed.

Another canny sticker-friendly strategy, which taps into the "more is more" collecto-mania currently gripping the visually motivated around the globe, is the artists' "pack-o-stickers". Yes, you buy them and then you leave them places, but you also buy a spare set, and ferret it away until one just like it pops up on the never-ending wish-list that is e-Bay. Stickers being ephemeral, chances are you might get lucky in a few years and find yourself sitting on a real rare object.

KILL BUNNY
NEW YORK
2002

AN EXAMPLE OF HOW NON-PERMANENT
INK AND WEATHERING CREATES A
UNIQUE IMAGE.

STOLENSPACE
LONDON
2002

A VERY TALL PERSON GOT THE
JUMP ON THIS ONE.

NEW YORK
2001

MAXIMUM VISIBILITY, MAXIMUM STEALTH
IN A LAUNDERETTE IN NEW YORK'S
EAST VILLAGE.

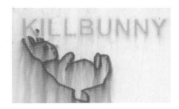

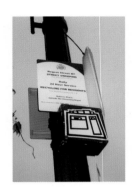

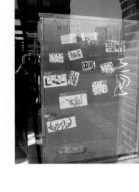

Distress, by way of sun, rain, grim and "over-pasting" is another crucial component in stickering's chance-y aesthetic, and a sign of extraordinary permanence on this usually temporary stage. With armies of city council workers sent out to scrape and peel our so-called public space, very little lasts forever. However, longevity isn't beyond this art form, with placement being 50% of its genius, as surreal juxtaposition often adds a comic extra something. So find an out of the way spot, i.e. a perch that's high, visible, highly unlikely and away from prying hands, and your mini masterpiece might just stick around to become a prominent and much loved city marker.

Some of the stickers that you'll see in this book you may recognise, as they could still be hanging around, or may have blanket-covered your neighbourhood in the recent past. More likely though, they're long gone. But they're here in this book because we went, "oohhh", when we saw them, and thought they deserved a second look. If we've snapped a sticker but can't figure out whose art we're honouring, we've left a space on the page. If you're in the know, just fill in the blanks.

Thanks to everyone who sent in their stuff; so much stuff, so little space. We could have crammed more in, but we wanted to show the stickers BIG, in all their gory detail. Having more in reserve, though, means that there's always the possibility of making another book...so keep us posted.

MORE INFO

Acamonchi sent this:
Gerardo Yepiz was born in Ensenada, Baja California, Mexico, but now lives in San Diego, USA. Acamonchi is Gerardo's side project, which celebrates and satirises Mexican popular culture via stencils, posters, graffiti and stickers.

AKAYISM sent this:
AKAYISM is altering your sleep patterns.
AKAYISM is redefining crime.
AKAYISM is as natural as jerking off first thing in the morning.
AKAYISM is a power no one took seriously and now a force to be reckoned with.
AKAYISM is skills you haven't even seen yet.
AKAYISM is teaching your little sister how to spit.
AKAYISM is making the streets a safer place.
AKAYISM is shit you already know, we're just here to remind you.

BETAMAXXX sent this:
The BETAMAXXX programme was designed to land humans on the Moon and bring them safely back to Earth, through the visual infiltration of the subconscious.

BETAMAXXX consists of; the honourable Nanda (artist, female rapper, flygirl, mad scientist), PhetOne (artist, grandpa, hero, stand-up comedian, the Swedish Chef), Rocz (artist, break dancer, designer, race car driver), Baschz (artist, freak genius, singer in a famous Dutch Gospel band) and Crackrock (low-life, project development generator, human beat box for the now infamous Jersey Singers, full-time psychic), DeLaLuge (junior member, designer, mascot, soon to be porn mogul).

Johan Boer sent this:
Stickerman started seven years ago as a joke. I was studying at the school of art in Rotterdam and combining my two subjects, illustration and outdoor advertising into an instant form of graffiti; the oversized sticker. I managed to keep it quiet, but wrote a thesis and graduated on this secret project. It gave people a good problem to think about; what to do with this form of pirating?

My aim was to create environmental extensions; I was making beautiful things and didn't want to just store them at home. When I put a sticker on a museum's window, it is as if it belongs there, only this time the artist has decided what is art, and not the institution.

Jon Burgerman sent this:
While studying art I got sick of lugging heavy portfolios, so I decided the best thing was to make smaller pieces of work that could easily fit in my pocket. Among the things I made were stickers, and I applied them around the university to raise awareness of my work and website. Perhaps it was an oversight to include my name, as the university figured out who had "vandalised" their greying lecture halls and mouldy canteens; a telling-off ensued.

Undeterred, I am now more careful where I stick them. Over the last couple of years I have sent out loads for free via my website. Stickers are a fantastic collecting and trading commodity and people really seem to like them. I've also wasted time creating loads of characters, and now they're scattered around in various guises, as stickers, flyers, t-shirts, on fag packets...

In answer to your question; I do eat burgers but mainly of the vegetarian kind. People think my name is made-up but it isn't. Who'd make up a name like 'Jon'?

Dave sent this:
Stickers are a fun, fast and cheap means of expression. Each sticker is an original drawing. They are intended to brighten the urban landscape with a little good natured subversion.

ETRON sent this:
E.T.R.O.N. (Emmerdeurs-Terroristes de Rue en Offensives Nihilites) undertake visual actions against shitty advertising for luxury products, junk food, porno and sexist stuff. Our goal isn't a moralistic one though; we want to show how the streets are full of consumerist propaganda and visual pollution, and to ridicule it...but having fun is more important than protesting, as the streets are our play areas!

ETRON means something like turd or shit in French, and roughly translates as troublemakers/ agitators/shitmakers and street terrorists in nihilistic attacks. ETRON is three people, l'emmerdeur, le chieur and le fouteur de merdes (also known as the k-k klan, which sounds like caca or poop in French). We act as one, like the famous "three musketeers", and are based in Toulouse, so our actions take place mainly in the south of France, but also in towns like Lyon, Paris and Barcelona in Spain.

The emergence of the new wave of street art, especially pictograms, in the late 1990s (by Andre, Invader, Zeus, La mano...) gave our shitty idea a new start...sometimes we use spray cans but only

for simple things or stencils, because unfortunately, none of us are spray-can technicians.

McDonald's ads are some of our favourite targets because we're particularly angry with the strategy of "mcdoommunicationadvertising" aimed at children. In France, one of the first sentences that children learn is "touche pas c'est caca" (don't touch that, it's poop), and we naively dream that some child may see our shits added to mcdo ads and rebel against the conditioning...(we just attack mcdo posters for pleasure, as we don't really believe our shits make an impact on consumer attitudes).

About our "technics"; ETRON is all about DIY — recycling commercial stickers (like a series of Slipknot stickers), computer-printed stickers, photocopied posters, stamps, stencils and throw-ups on walls.

About our "influences"; we particularly appreciate; le 33 for their humour and fun in changing/hacking advertising posters; Zeus, especially for his actions using red paint shots on top models' posters or his recent ad kidnapping in Berlin; Banksy for the impact of his slogans and images; Adbusters and their French alter-ego Antipub; Billboarding Liberation Actions; Influenza, and MCA of Evil Design.

Influenza sent this:
The "15,000 most popular words in advertising (in modern order) project" is an ongoing public space intervention. The ironic element of the project works best in countries where they don't speak English but still use advertising clichés, like supercool, ultracheap, megaburger, etc. These stickers work as annoying noise in the streets, emphasising the cheap tactic of making language more contemporary simply by using "American" words in ad slogans.

In some countries, like the former Communist states in eastern Europe, where very few people speak English, these ad slogans were often the only English words visible in public, until now that is; so the stickers function as a herald of what is to come.

JAKe sent this:
I'm part of the Detonator Collective, along with ZEEL, and do a mixture of stuff including record sleeves and t-shirts, as well as stickers.

My favourite ever sticker was a black and white diamond CORROSIVE warning sticker that my Dad gave me when I was six. I've been fascinated by them ever since. I'd like to do a range that would be given away free in cereal boxes...die-cut, chrome and black, with glow in the dark highlights.

Dom Murphy sent this:

About five years ago, a sticker on the London Underground caught my eye. It emulated a public information sticker like, "This seat is reserved for the elderly". On closer inspection I discovered that it was really for a church! I liked the subversive way the message was broadcast. After that I began noticing odd stickers everywhere and I was addicted; stickers are clean; instant; cheap; high quality and collectable.

StickerNation began at the turn of 2000. The intention was to give artists a chance to spread their work across the globe, for free. Artists sent in work that was formatted into A4 PDF files and made available for download; then the work could be printed onto blank sticker paper and "distributed". It's always been a personal project, so keeping it updated was the biggest problem. As it grew from 100 to 10,000 visitors a week it needed a dedicated commitment of time and money, both of which were scarce. But it reopened this autumn with a new design and new technology. Now representatives around the world report on their local sticker scene and upload photos and news. StickerNation was the first regular documentation of sticker culture and the intention is to make it the definitive resource. The concept, design and content is by me, Dom Murphy; the backend development is by Duo.

One last word; if you're going to tag, why tag a sticker?

Mysterious AI sent this:

I like stickers for the same reasons that I like graffiti; the mass interruption; the exposure. I make stickers at home in the warm, with a cup of tea. I make monsters to watch over the city. It's not about coverage...I'd rather place ten rockin' stickers than a hundred throw-aways.

Random von NotHaus sent this:

I've been assaulting Los Angeles for several years now. Before moving to the big city I painted graffiti, but gave that up to focus on posters and stickers. The Buff Monster, is my current project; he's a humorous little character named after anti-graffiti clean-up efforts. People in LA recognise the posters and stickers, but there are also paintings, tags and installations around the city. If I'm home at night, I make paintings and silkscreen prints about the Buff Monster, and these and other paintings have been shown across the USA.

ORKO sent this:

Festering under the dangerous supervision of the bathing primates sits the house of ORKO. A tribe that stare vacantly at the darkest corners of your mind with one main aim in life...to smash the system. "What system??" we hear you ask; the system that sees men treated like monkeys. Ladies and Gentlemen, it's time to join the revolution and beat down the leaders. Join THE HOUSE OF ORKO in our quest for domination. The barriers are there to be broken, we can win this.

Andy Sargent at Seven nine sent this:

Operating out of Melbourne, Seven nine represents a totally free, creative outlet, applied to illustration and t-shirt design. Above all else, Seven nine verges on escapism and nonsensical imagery. People sometimes take their surroundings for granted, never stopping to admire the finer points, never allowing themselves to feel comfortable in their own neighbourhood. Sometimes all we need are subtle prompts from complete strangers and vague reminders of meetings never made.

Space3 sent this:

In 1994, at the art academy in Hertogenbosch, a graphic designer and an illustrator teamed up to do a poster for a friend who was a DJ. We knew each other from our teenage days, when we hung out in the graffiti scene. We did some tagging in the streets of Eindhoven, but we weren't that good. We were better at type and image, so we started Space3, hanging out in our joint, listening to Kool Keith's "We are the Horseman, enter your spaceship". Then a simple, graphic UFO entered the Illustrator 5 window on the monitor. We made a logo with the space ships and a new Space3 type based on Chigaco, "the Mac type".

In the spare time from our commissioned work we wanted to make the streets of our city visually more attractive; we hated the big, money-spending ad campaigns with no visual appeal, but whose only goal was to sell. Space3 wanted to enrich the streets with graphics that were a visual riddle with no answer.

We've heard a lot of comments on our street interventions; what's this crazy stuff? Who are those fools? Where do they come from? What the fuck does it means? How can I get my hands on some posters? Meanwhile, we stayed anonymous because it gave our actions and images more power. Eight years on we still do street actions, meaning Xeroxed or screen-printed paper, with glue. We also collaborate with Erosie, Sol Crew and Influenza, meaning we do projects together and go on city trips to leave our graphics and other visuals all over.

Stolenspace sent this about two projects, D*Face and INSTANT:

Like a snail leaving its sticky trail, I leave my stickers, always on the look-out for that ultimate spot. The city is the gallery; stickers, the canvas being exhibited. I see every smooth surface as my exhibition space, hanging my marker-drawn visuals at every opportunity; the higher and cleaner the spot, the better the gallery...the longer the show!

I created a character, D*Face, whose personality could evolve, like a dysfunctional fucked-up Mickey Mouse who likes tags and drippy paint. Hanging out at their favourite spots – grey bus control boxes and lamp posts – evolving with every individual rendering. I want people to be intrigued by these faces peering down at them, to put a smile on their face...or a frown on their forehead!

In an era of mass production and fast moving, saturated media, we consumers are encouraged to mentally escape into idealised lifestyles. We use brands to piece together who we are and create new, improved identities. INSTANT takes this one step further by making tangible an absurd idea; selling a brand, and playing on "supply and demand" culture, where everything is wanted yesterday, in an instant.

I'd just like to thank The Royal Mail for being the unofficial sponsor of sticker bombers.

Tofer sent this:

I think of the public sphere as an alternative to the traditional white cube that is a gallery, and I want as many people to see my art as possible. It acts as a kind of visual intermission, a (pleasurable) break from all the visual garbage. Most of it is done guerilla; however, I came from a graffiti background and realised that that type of public art has an extremely limited audience. That's when I designed the Tofer icon, silkscreened onto a vinyl sticker, and from the sticker came the poster.

My goal with using this alternative media (compared to aerosol) is to reach a wider audience. While society has labelled aerosol paint as a tool for destruction, paper and vinyl are seen as harmless. After becoming familiar and comfortable with this sticking-application, I decided to expand my vocabulary and began designing more iconographic imagery. In Los Angeles the majority of people commute by automobile, so you have about a second to digest imagery while passing by. So, I produce pleasurable images that can be easily read, as well as remembered.

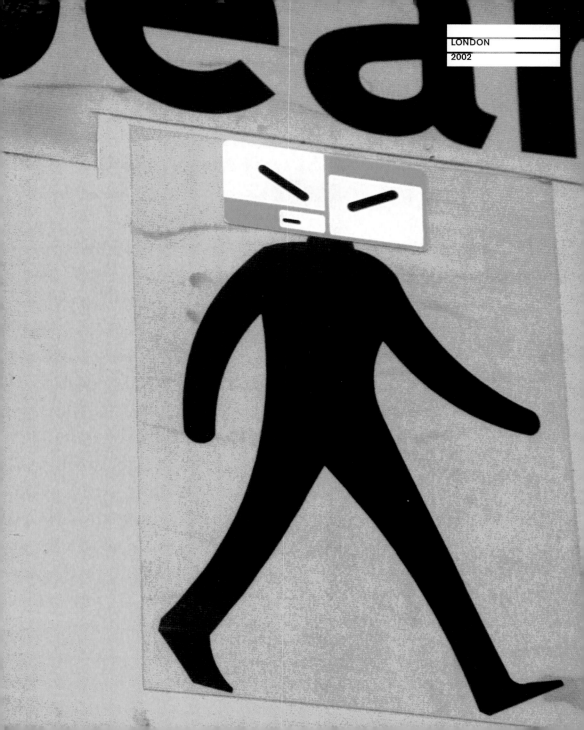

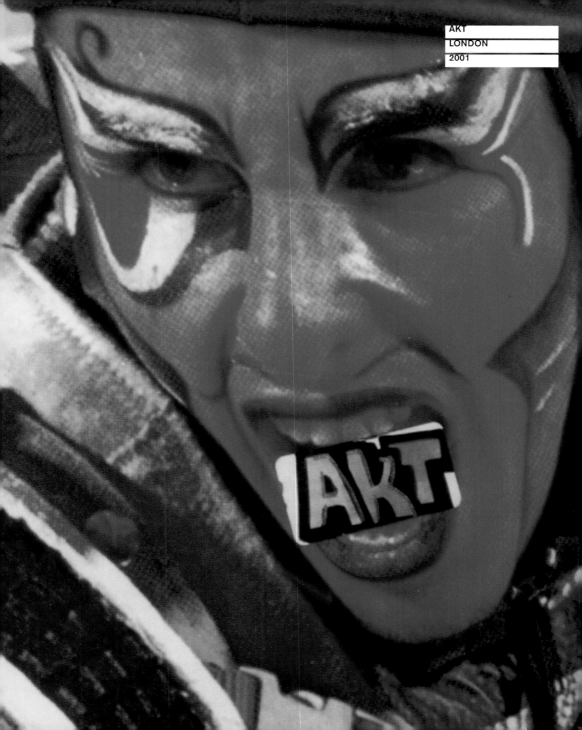

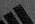

PEEL N STICK ON
METAL-PLASTIC
WOOD-GLASS

SOMESHINE™ 84
MIA

When Closed
Use 24 Hour
Accessible
Toilet in -
Broadwick
Street

For Details of
Other Toilets
and Times of
Opening
Telephone
020 7641 2000

City of Westminster

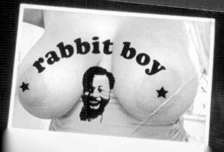

rabbit boy

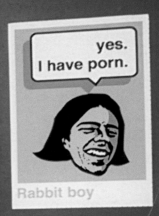

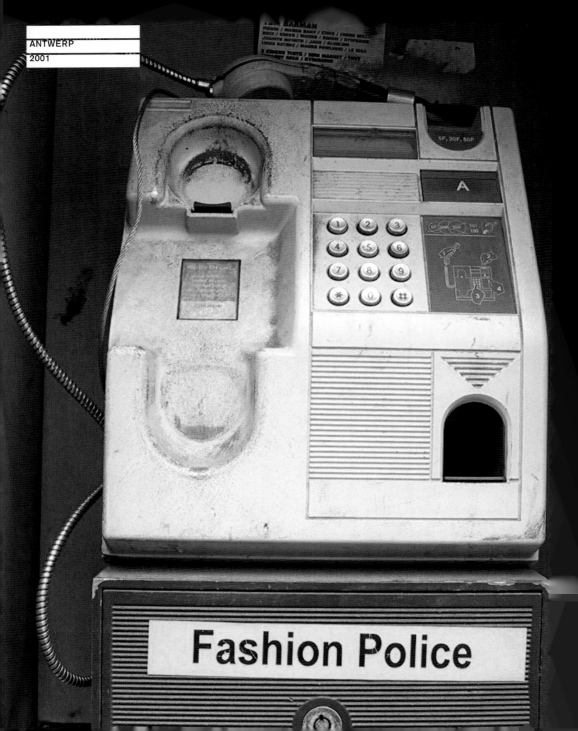

ANTWERP
2001

Fashion Police

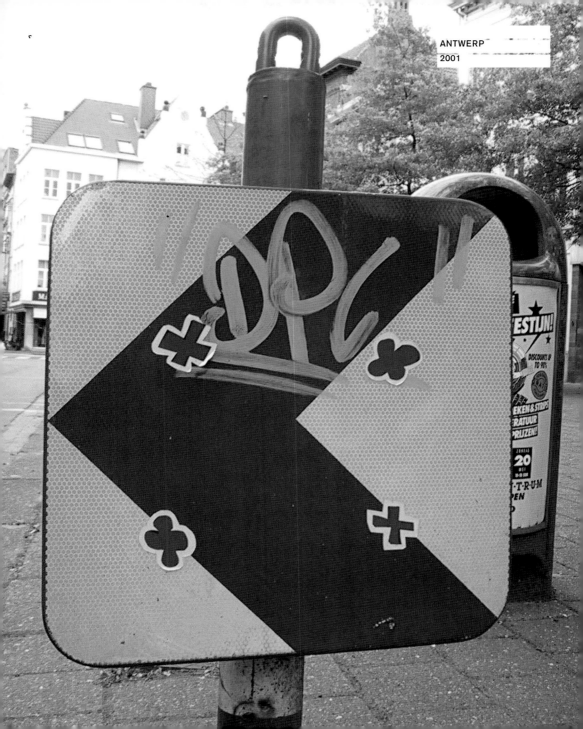

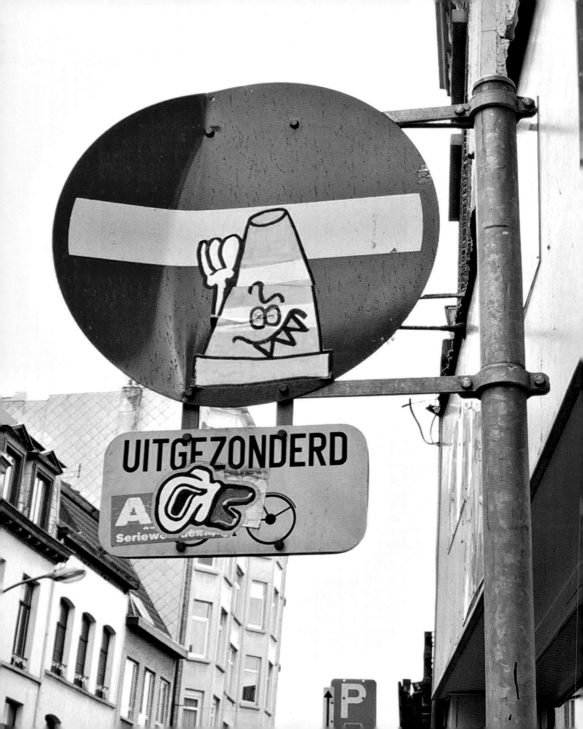

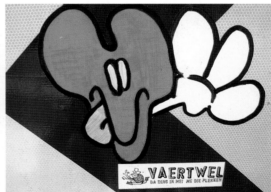
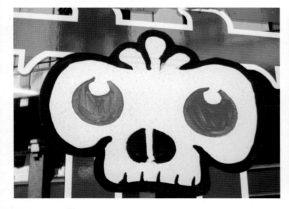
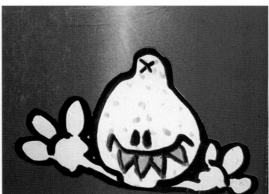

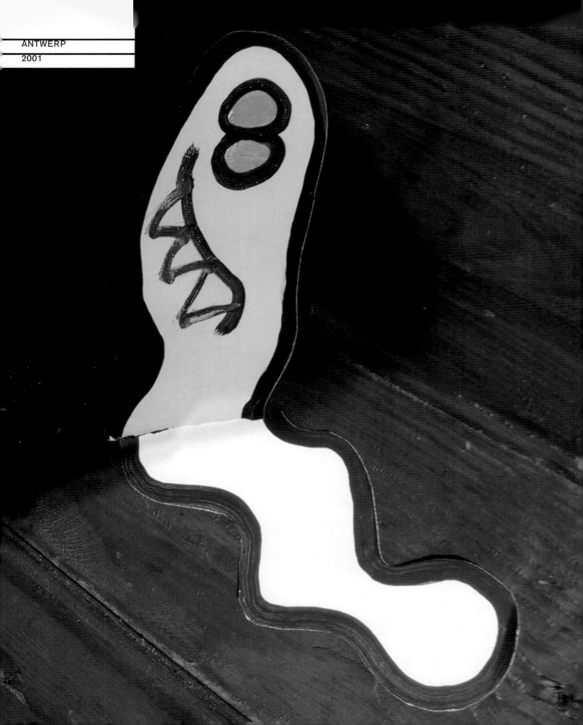

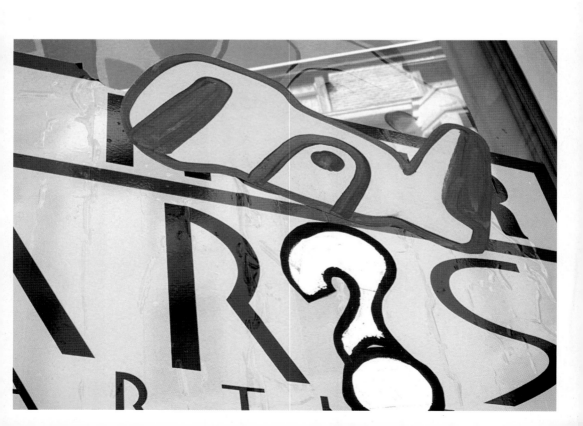

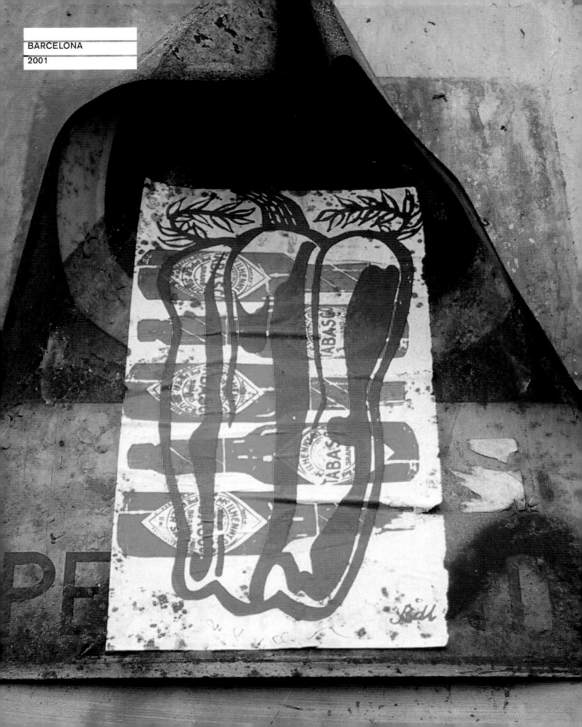

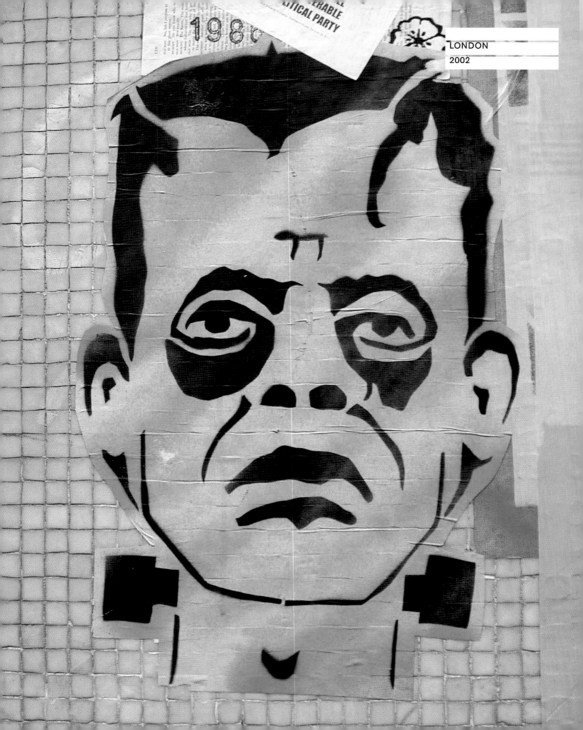

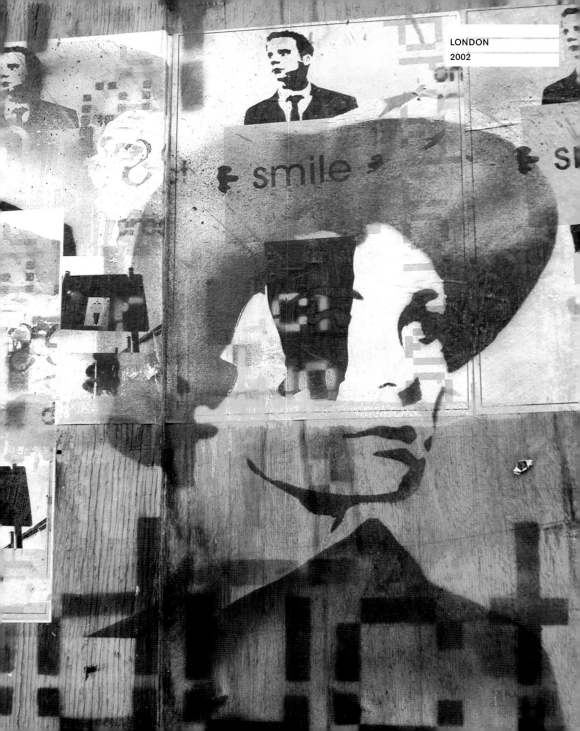

smile

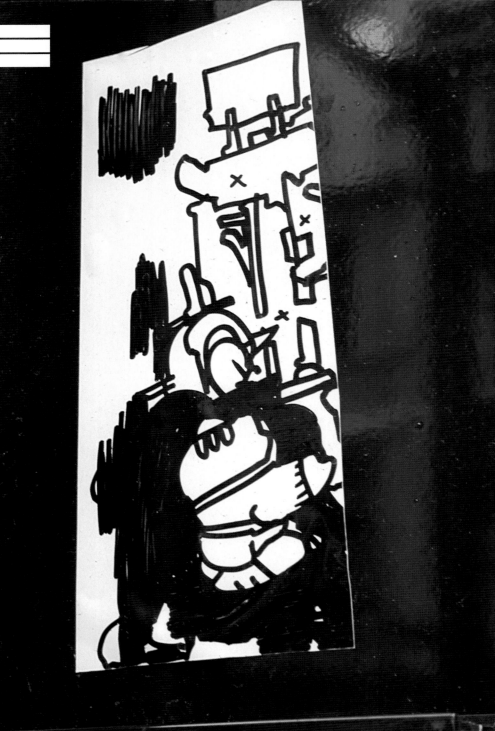

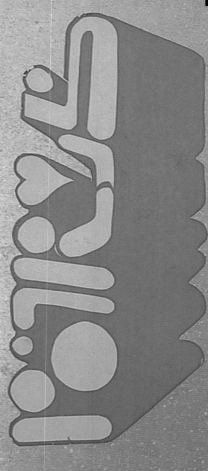

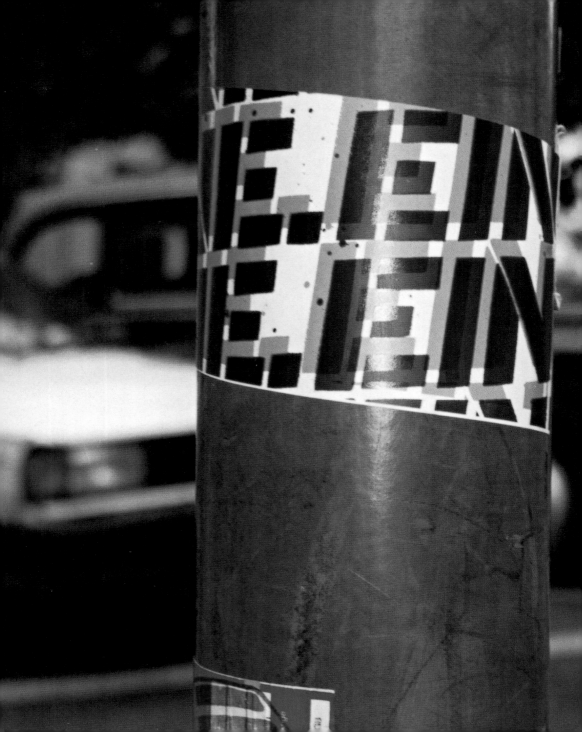

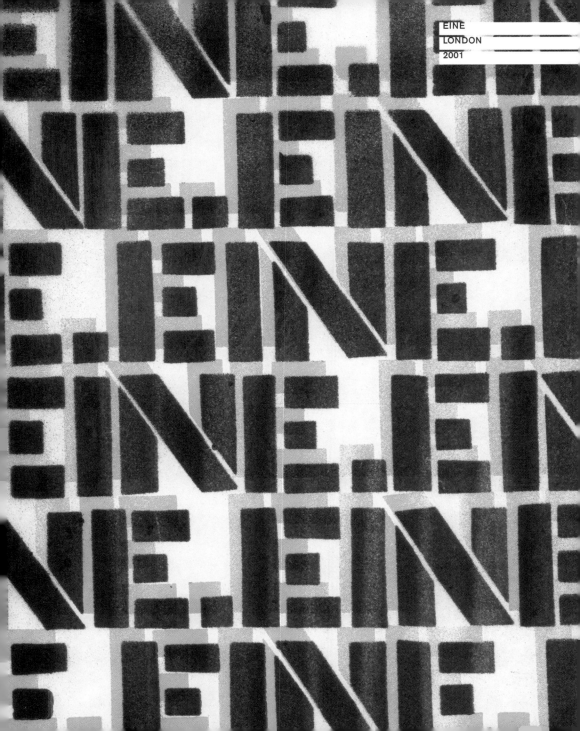

EINE
LONDON
2001

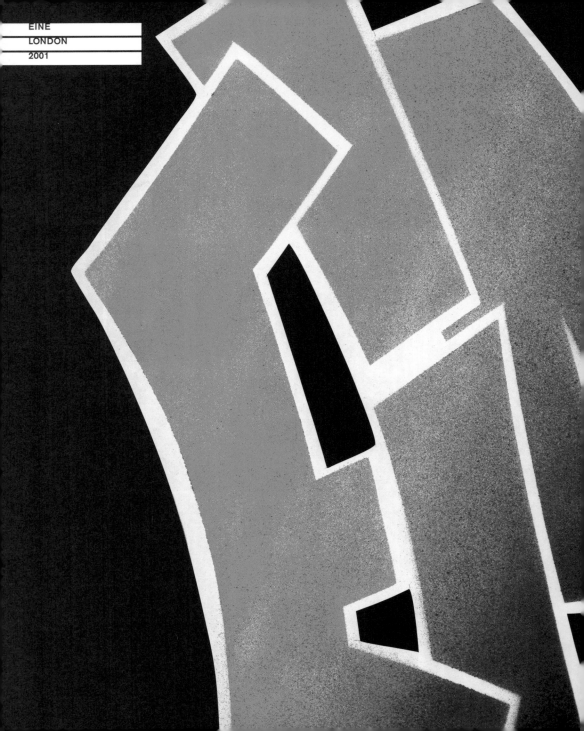

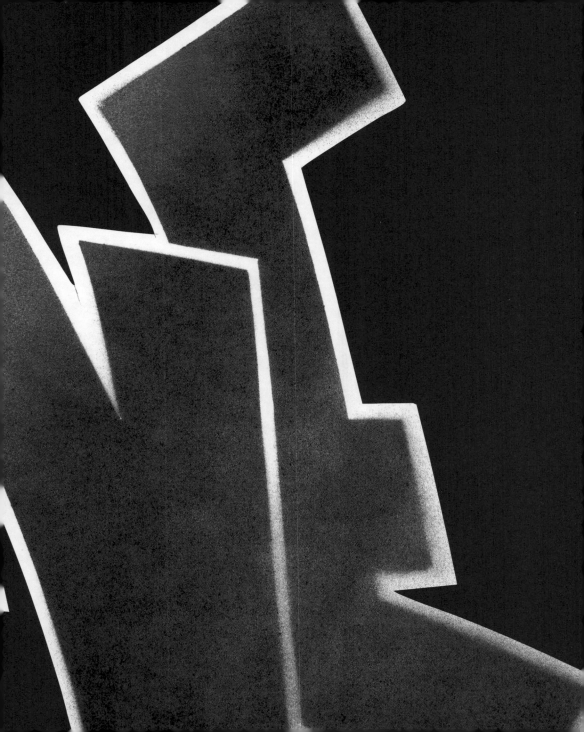

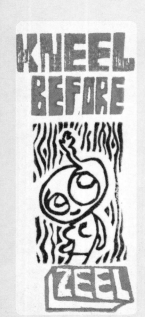

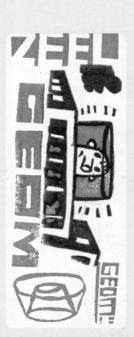

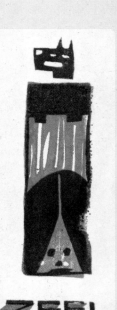

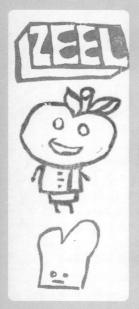

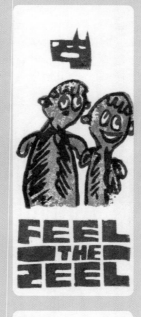

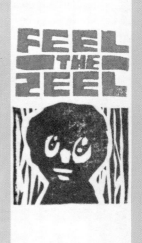

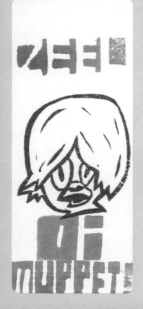

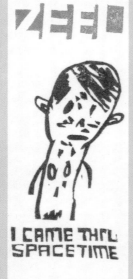

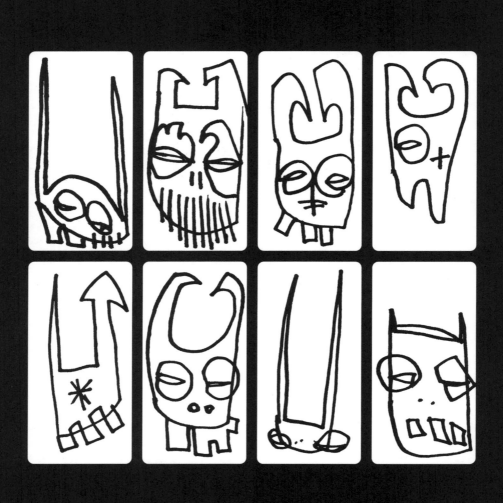

Royal Mail®

international registered

| express ✗ | signed for ✓ | compensation ✓
for loss or damage |

Your item is tracked until it leaves the UK.
We can't guarantee delivery time in other countries.

write details of where your item is going

Name

Address

Postcode
Country

This service is not available to all
countries. Check at a post office.

RV 3869 7304 9GB

For most countries you can claim up to £500
compensation for lost or damaged items

tick if your item is worth more than £500 and
you want a compensation limit of up to £2,200

write your address on the back of the package
and your item's value on the front in words and
numbers as follows: insure for xxx pounds (£XXX)

hand this label and your package in at a post office

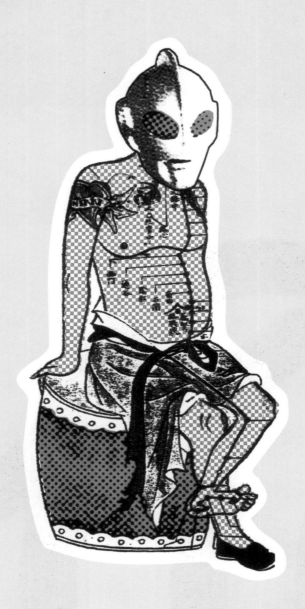

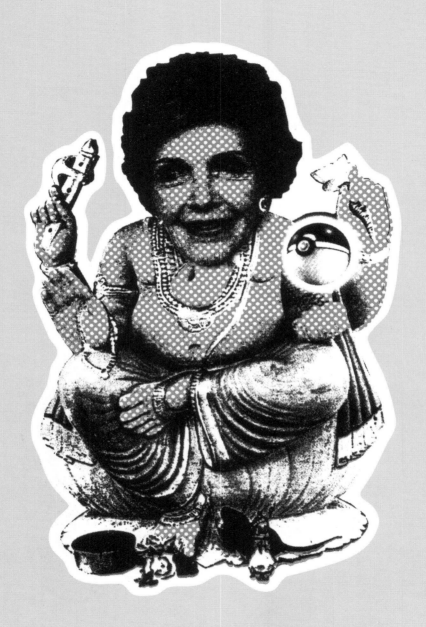

BLOTCH
WOMAN

...umph), in her *Etiquette for Every Day* (1902), is of cheated bridegrooms creating angry scenes in vestries on finding that their brides had understated their ages. Girls who cheated were extremely careful, she says, not to choose a church which insisted on the production of birth certificates. Certain deceived bridegrooms had been strongly tempted to repudiate the match, but this was a difficult course for a gentleman.

Some of these unimaginably surprised bridegrooms go straight ... have ... uncomfortable quarter of an hour. The most ... in the deception as well as he ... false... ... to the quit con-vincing.

It was safe to ... those names were in average. Burke was too polite to quote them ... Lodge or not. There is more obligation... ... in the Edwardian scene than ... Huntington who knows ... bits of information on her ... social ... strong that it is obligatory for a ... green ... an engagement ring

BLOTCH
WOMAN

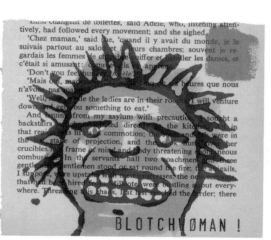

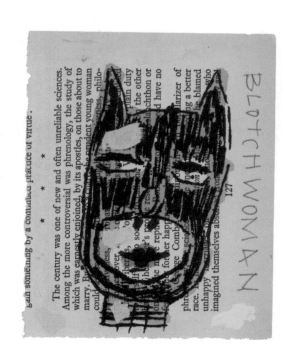

He asked me if I liked Los Angeles, and I said it was a good quiet place to have an affair, and then she said, "But could you have an affair there?"

And Doug Christmas was just afraid that Ron or Leva had had a friend keep the receptionist busy while he walked in, took one of my drawings out of the frame, rolled it under his arm, and walked out. Then he had the nerve to try to sell it back to the gallery and they pressed charges and the police said he had a record a mile long.

Fred's outfits on this trip were his new clothes from London. They're really long so they look like Indian tunics—and Sue Mengers said to Fred, "In New York your hair is slicked back, you wear beautiful suits and gorgeous ties, and in L.A. your shirt's hanging out, there's no jacket, no tie"—oh I know you you probably said, 'This is good enough for those Hollywood Jews.'"

Sunday, September 24, 1978—Los Angeles

We went to pick up Ursula Andress and when she got to the opening she was dragged through the crowd. Marisa was wearing a gold sequined suit and a gold sequined jacket and skin-tight black stretch pants—you could see her everything. Her sister Berry was wearing a blue and white striped cotton dress. Sue was wearing a flowing hot pink chiffon gown. Two or three thousand, five hundred people showed up. Then we got it all so jammed that I got into my car real quick and was taken to the restaurant, Robert's, where the party was. It was on the beach.

A guy came over and said that he had the biggest cock so I offered to sign it and Marisa got so excited she leaned over to look at the cock and her hair caught on fire in the flames of a candle—it was like instant punishment. And Ken Harrison was at the opening but he got lost in the shuffle, and Sue was dying to meet him. Everyone was dying to meet him because of his big cock in my show.

Monday, September 25, 1978—Los Angeles—New York

The new *Interview* arrived from New York and Fran's column was so boring I told Bob we should fire her. So we had a fight. Barbara Allen woke us up and she took us to Giorgio's in Beverly Hills to sell some ads and Fred and Gale Hayman who own it were thrilled to see me. And now they're selling mink V-neck sweaters and I said, "Oh I'd love one." and he said, "I'll sell it to you wholesale." And then I realized I'd really stuck my foot in it and I said, "Oh no no no. I'll just pick one up the next time I'm in town."

Johnny Casablancas was checking into the hotel and a bunch of Rastafarians were out in front because Bob Marley was staying there (maid tips $30, concierge tips $20, bellboy tips $10, limo driver $10, Redcap tip $5, magazines for the plane $14.50).

The plane sat in the air port for five hours having its fuel system repaired. Meanwhile, the talk of the town was the air crash in San Diego that morning that killed 150 people.

BLOTCHWØMAN !

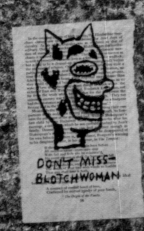

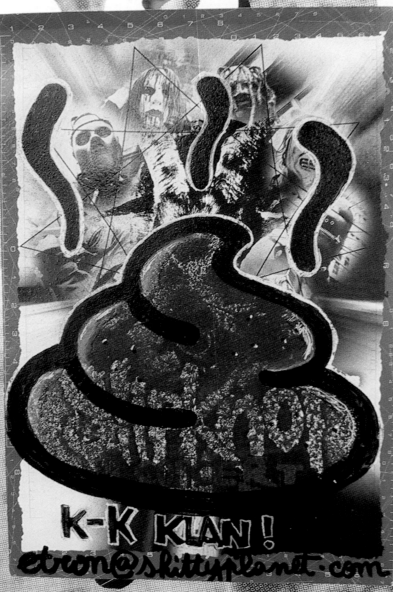

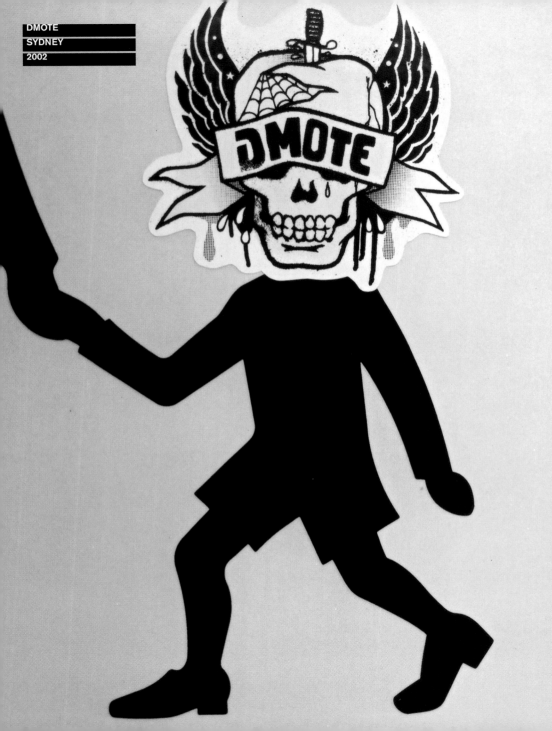

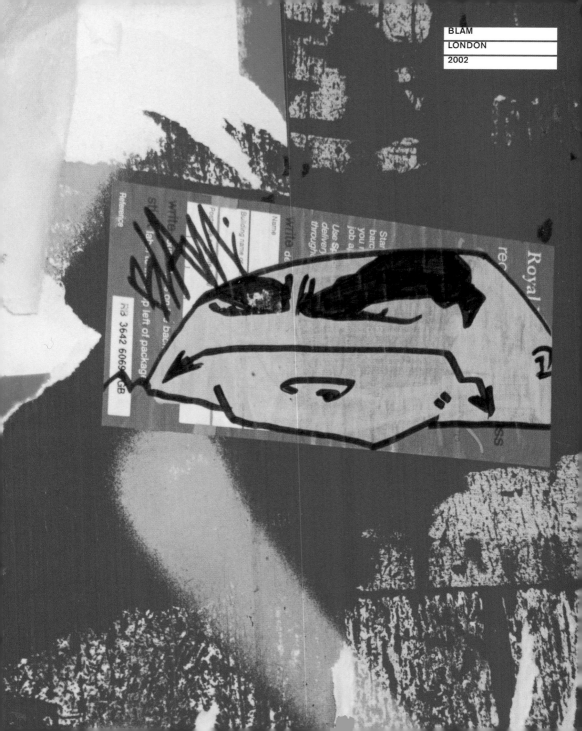

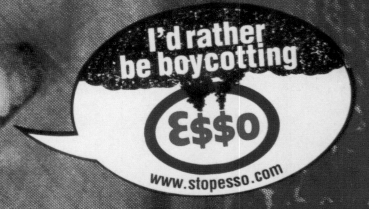

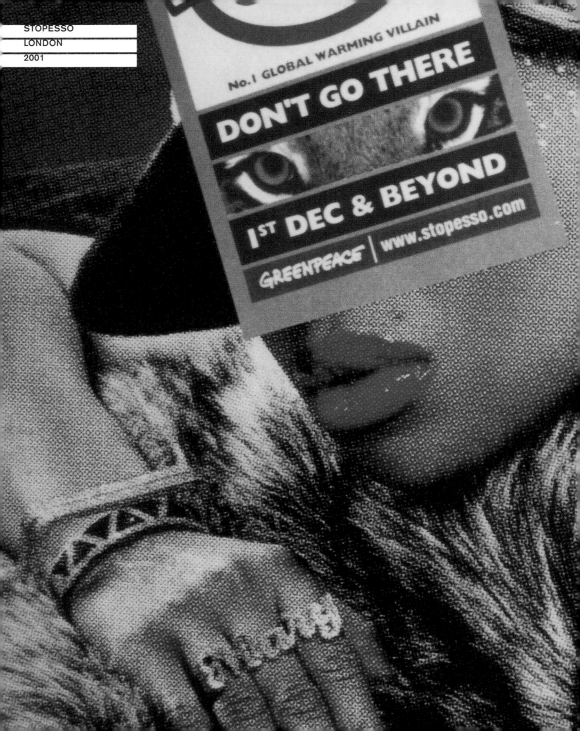

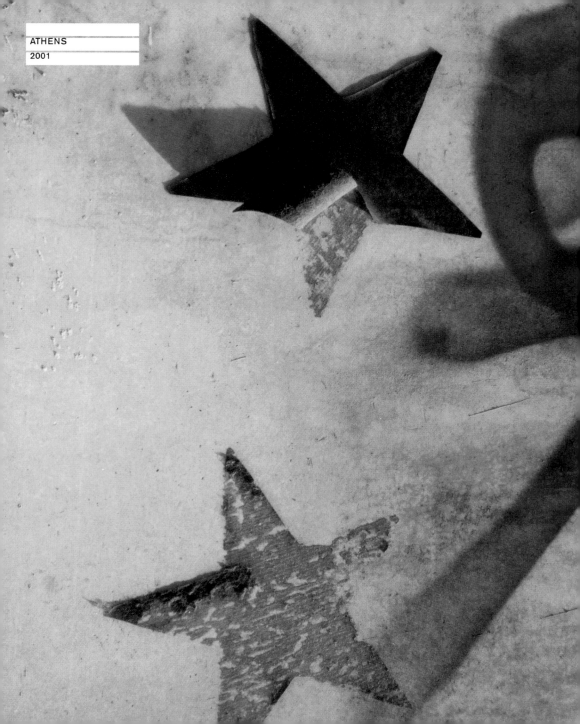

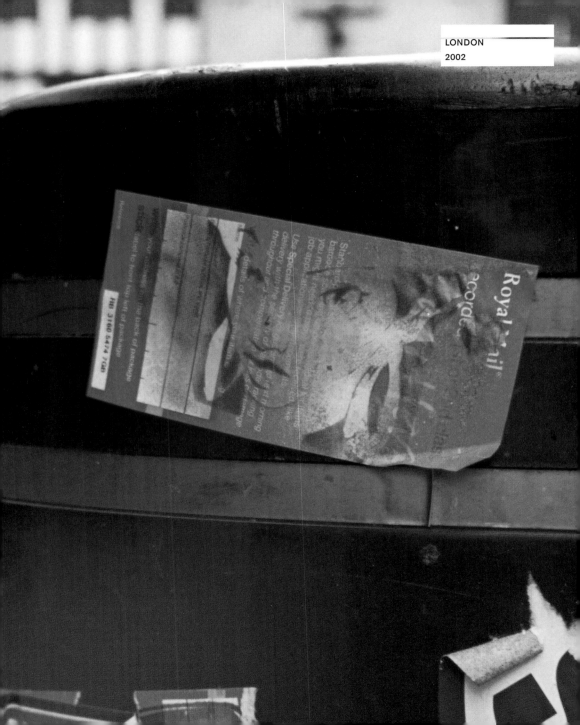

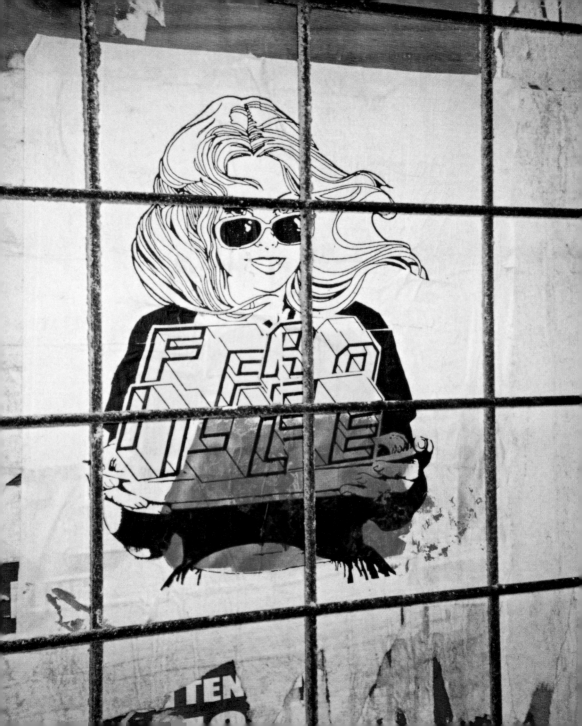

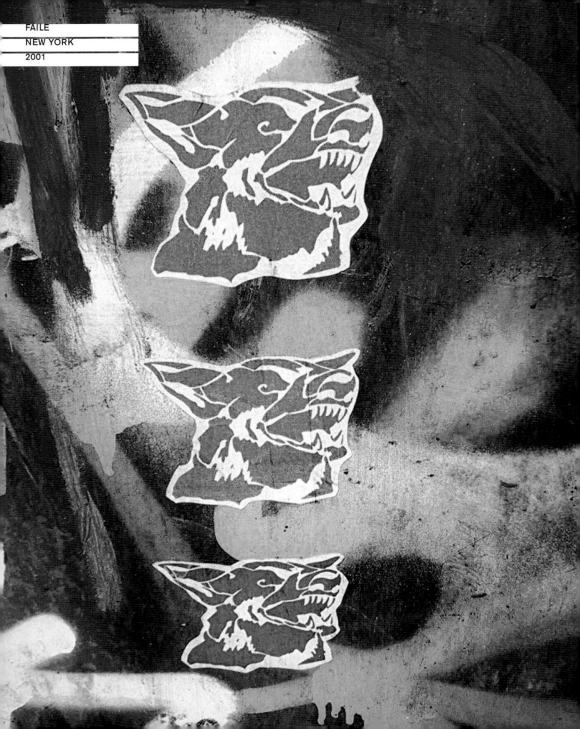

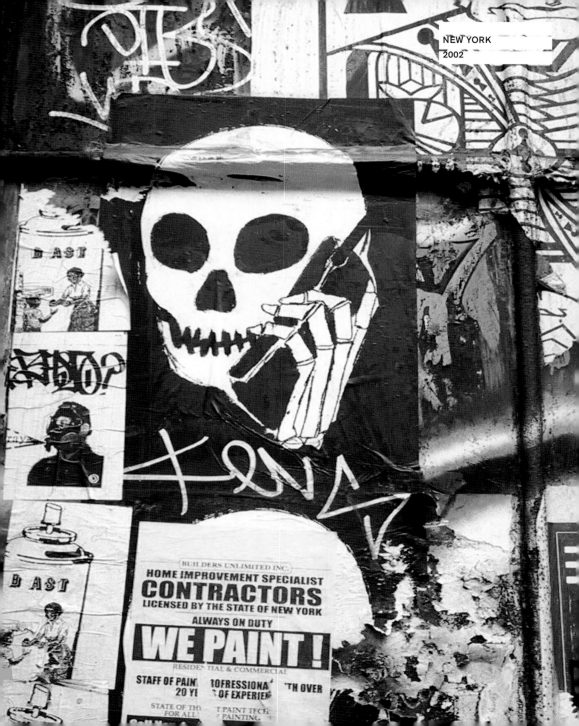

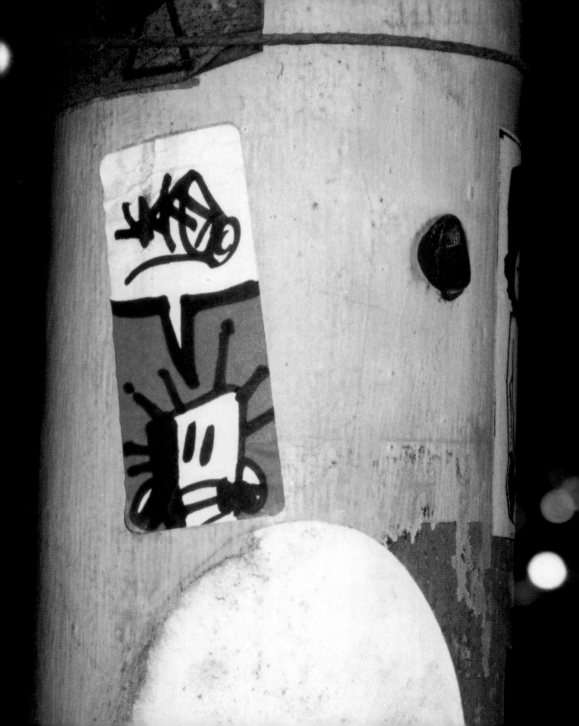

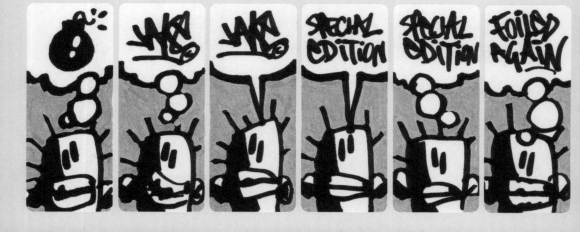

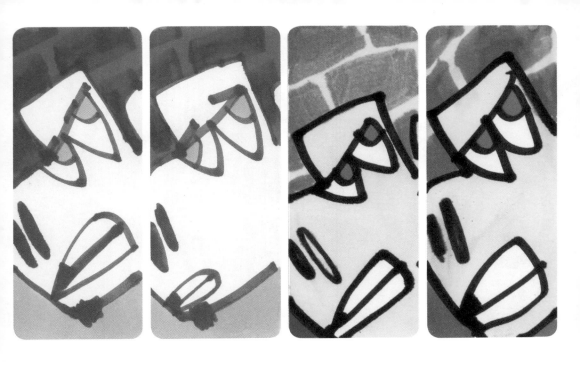

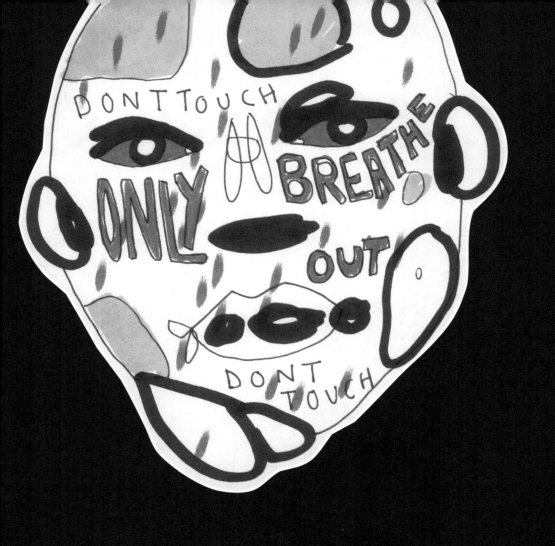

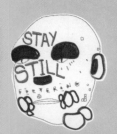

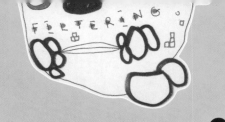

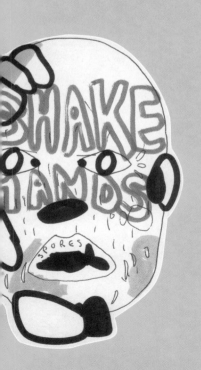

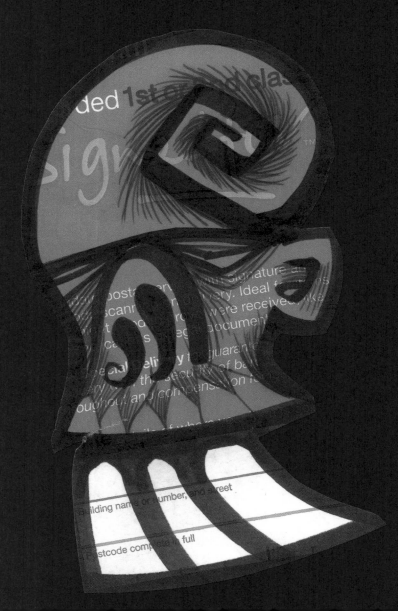

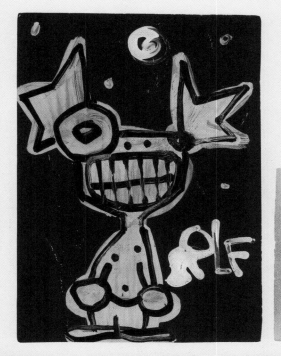

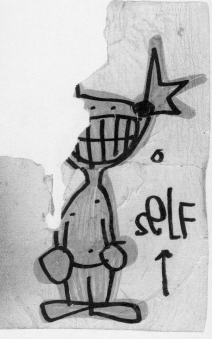

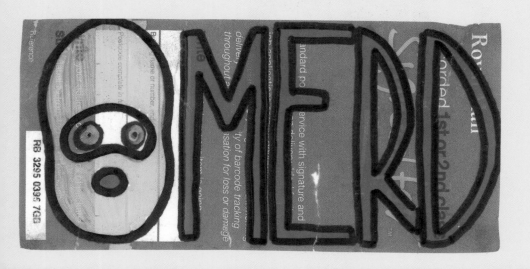

Royal Mail®

specialdelivery

ranteed next working day by 12 noon

write details of where your item is going

Name:

You auto
compe atio

tick if y 0 and you
want a high n extra price

Tick one level to 1 p to £2,500

write your address ack of the package

hand e label and your ost office

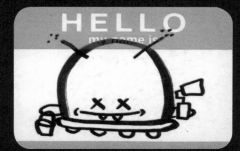

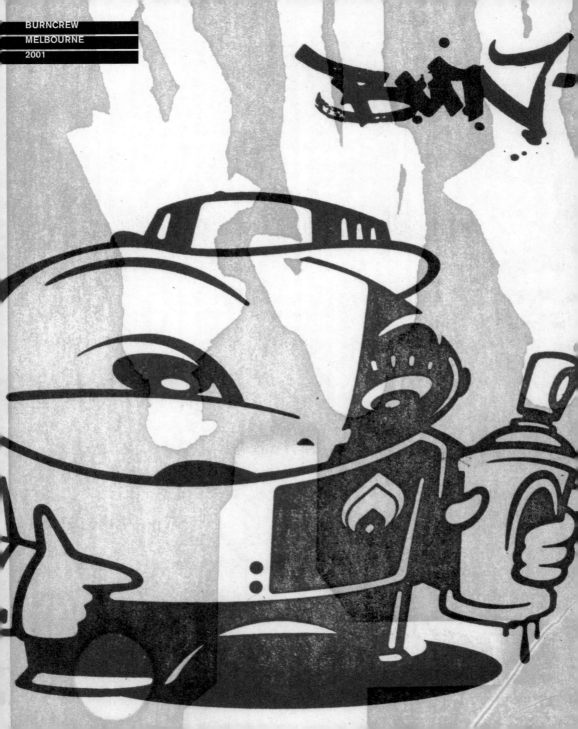

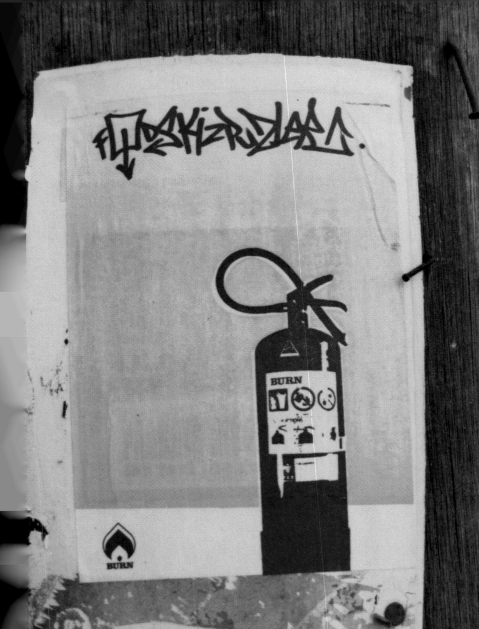

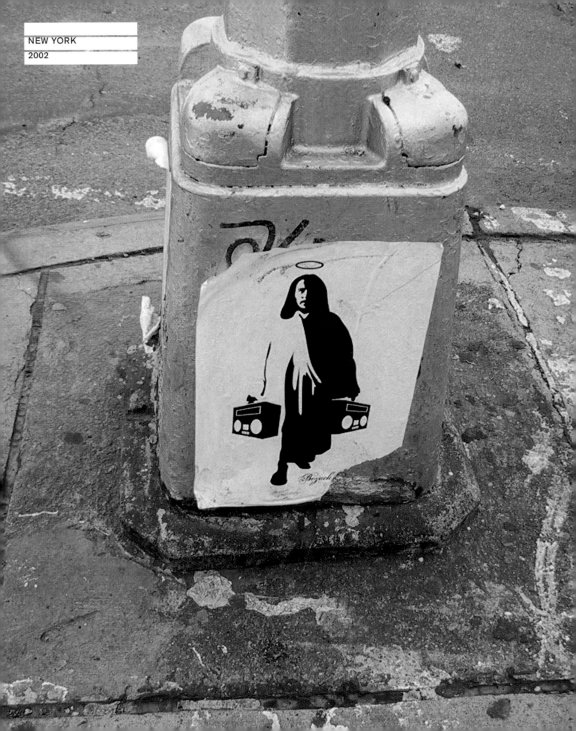

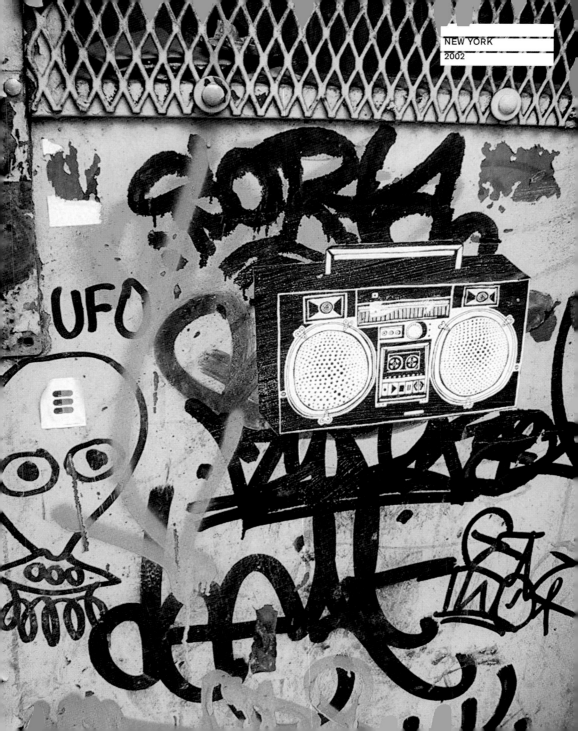

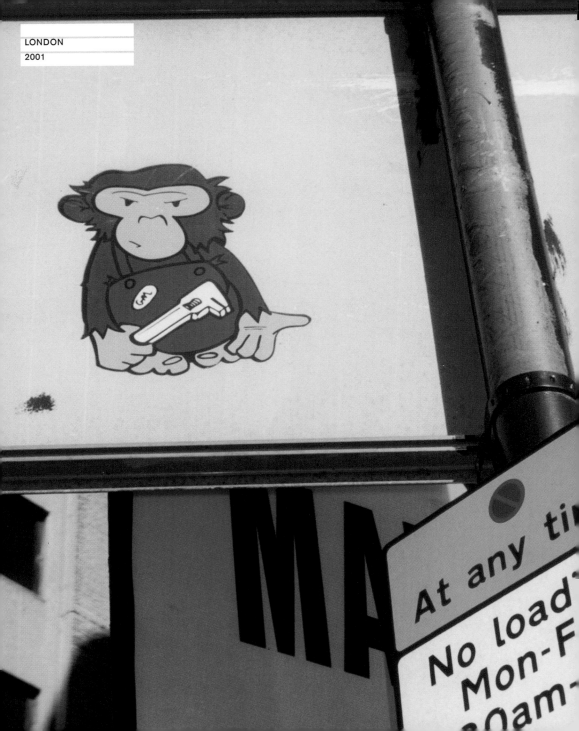

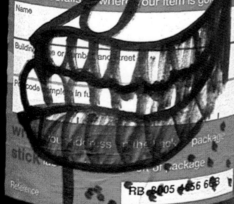

Mail®

...class

Sta...dard postal service with signature ...
bar...de scanning on delivery. Ideal for item...
you ...ight need to prove were received. ...e
job a...plications or leg... ...

Use **Special Deliv**...y for ...ranteedorning
deliv...y with the secu... ...arco...e tra...
throug...

write details ... wher... your item is goi...

Name

Building ...e or ...mb... and ...treet

P...code ...mple... in f...

w... ...you... ...dd...ss ... the back ... package
stick...

Reference RB ...005 ...56 6...

...BONEFRESH

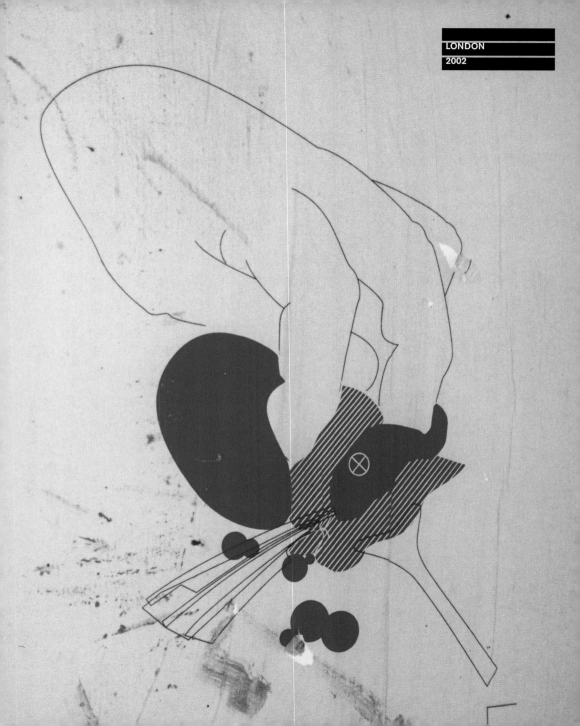

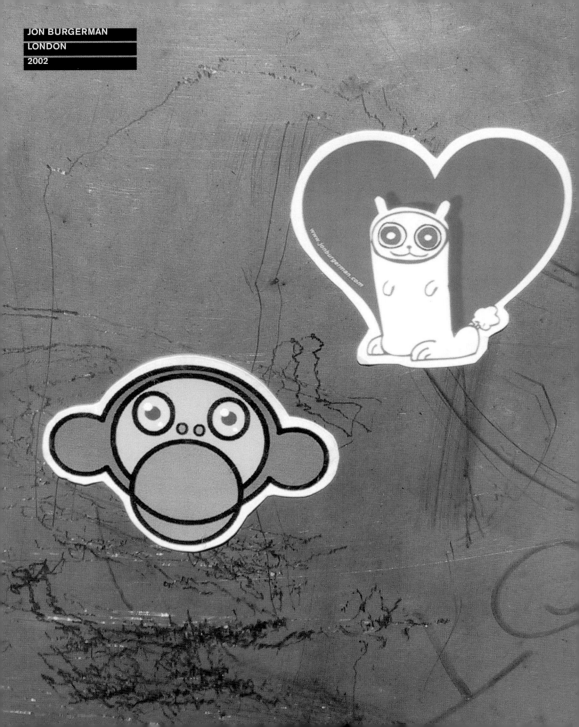

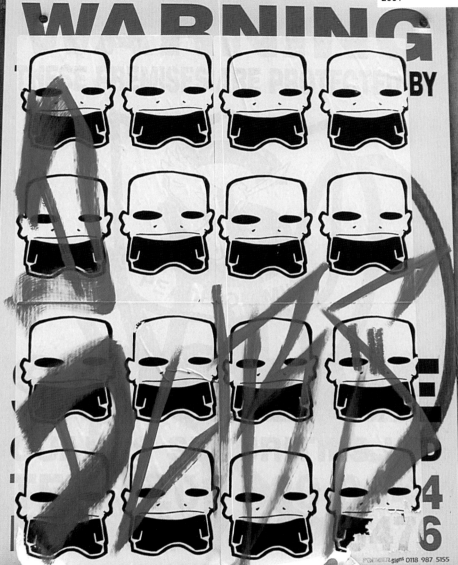

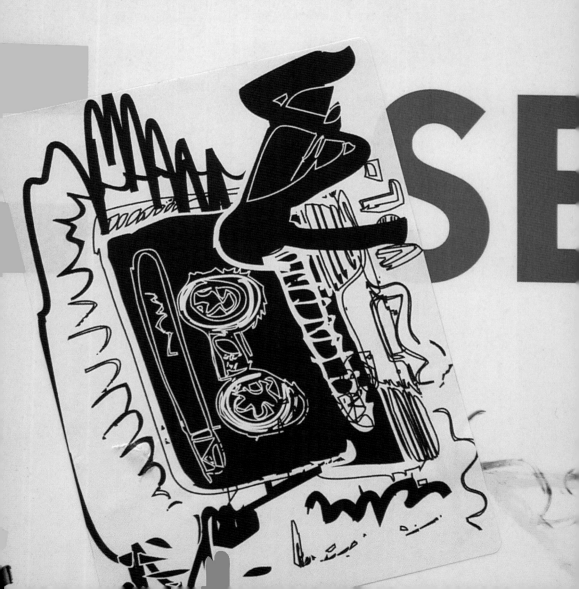

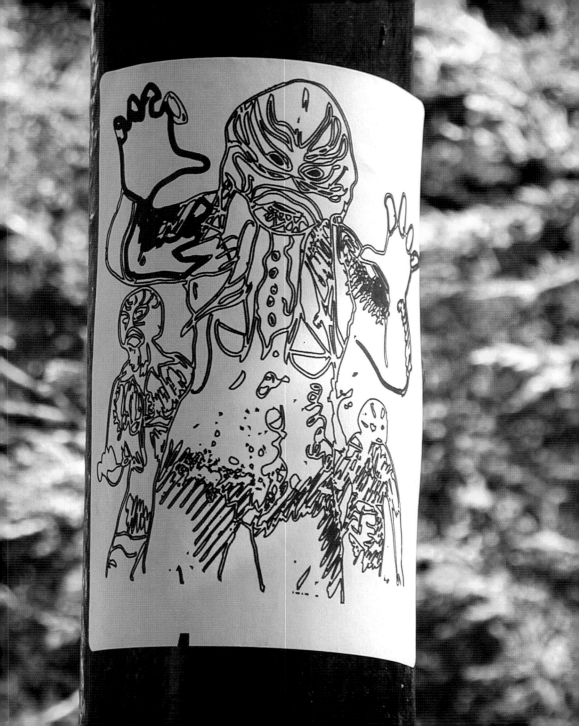

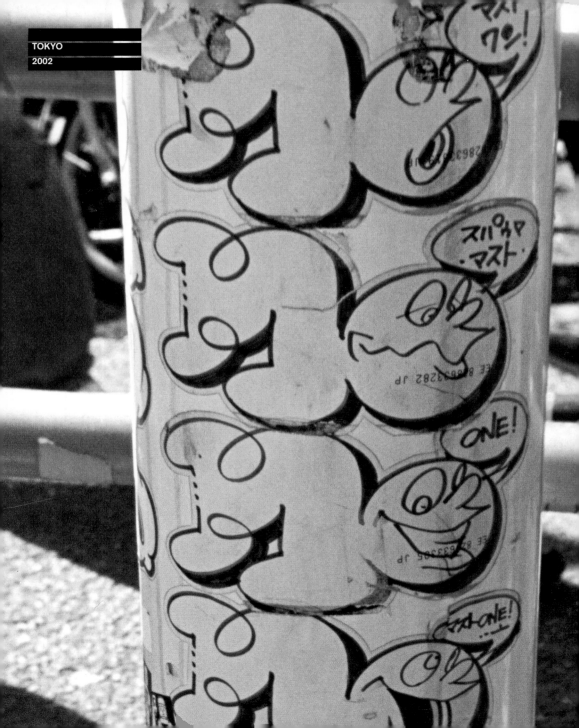

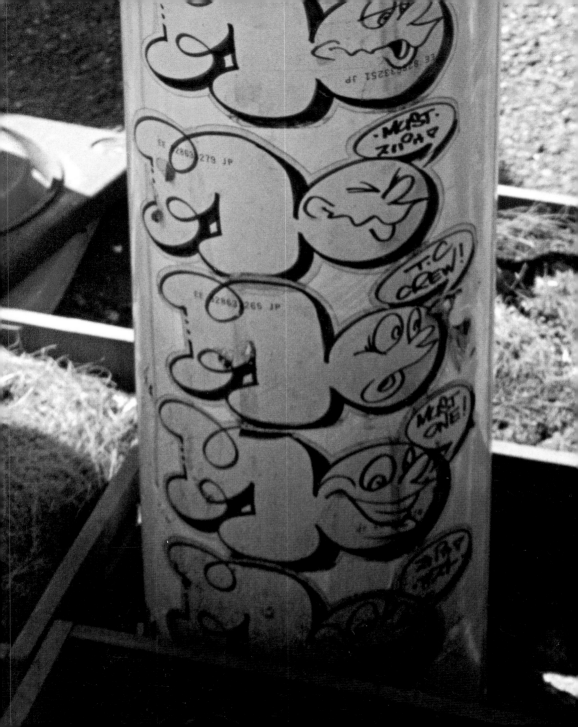

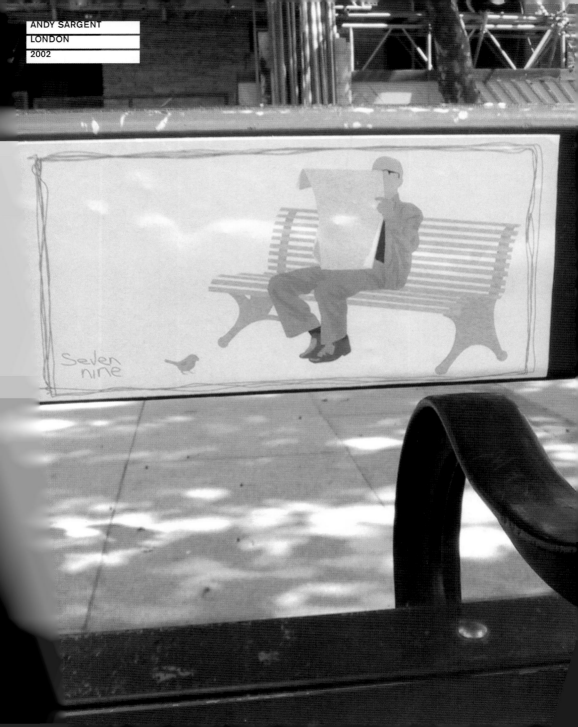

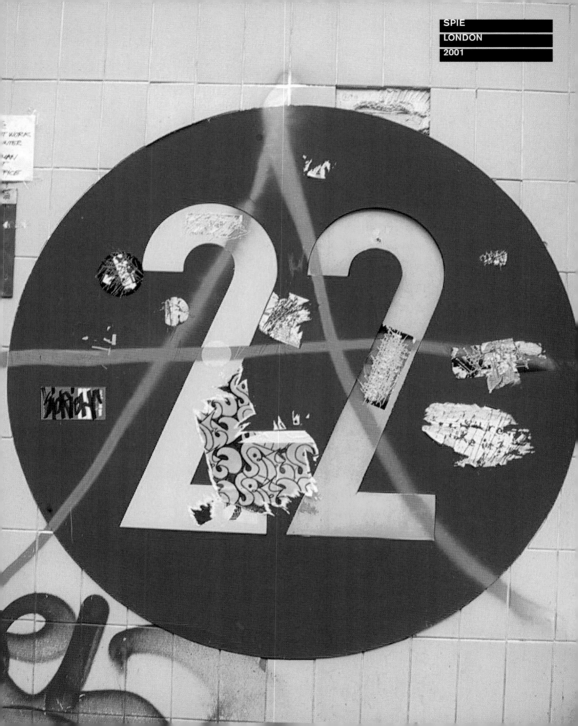

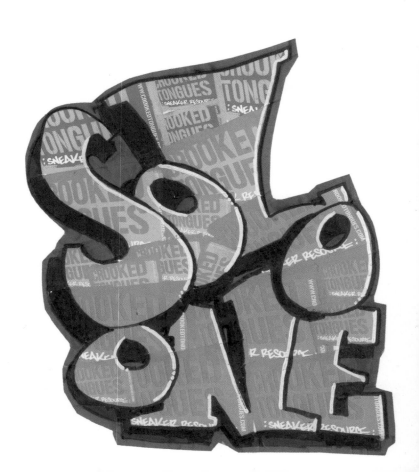

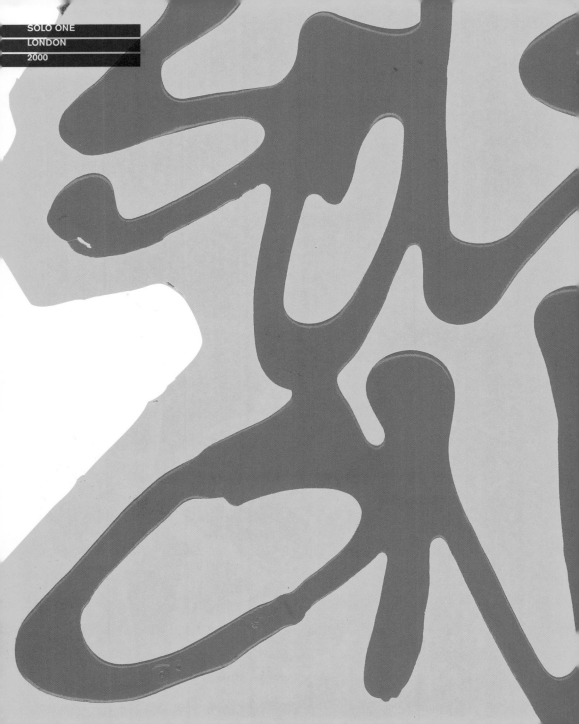

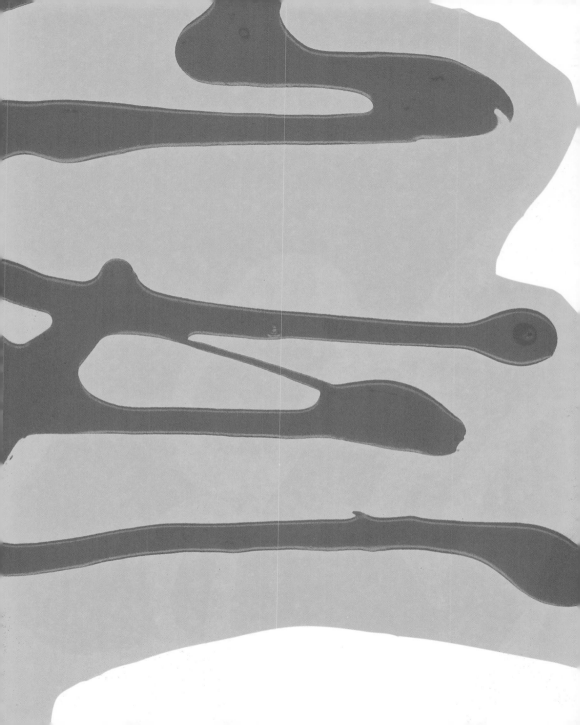

Standa...
barcode s...
you might r...
job applica...

Use **Specia**...
delivery wit...
...hout

W...

Name...

Pos...

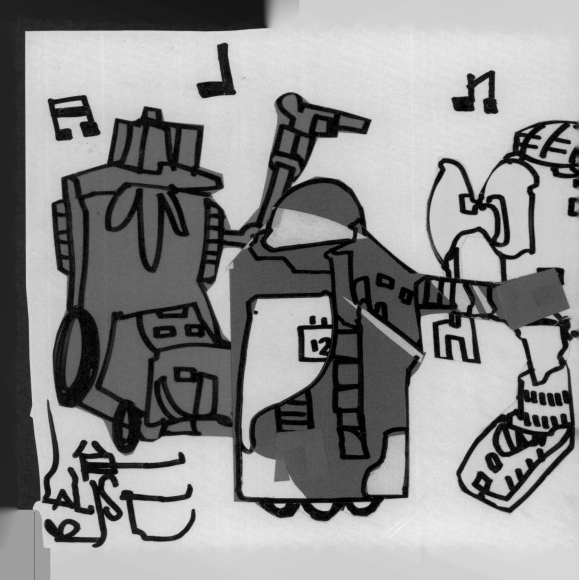

IN ROBOCITY. THE MACHINES WOULD GO TO THE CLUBS ON FRIDAY.

EVENTUALLY, ONE WOULD GET TOO DRUNK AND DO "THE HUMAN" ON THE DANCEFLOOR.

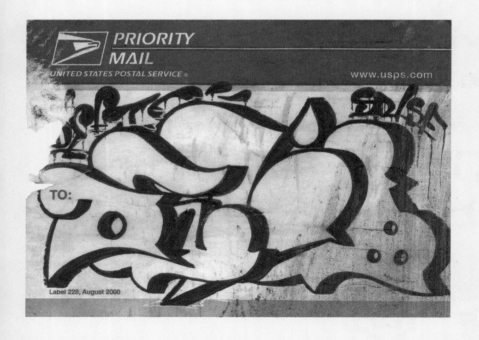

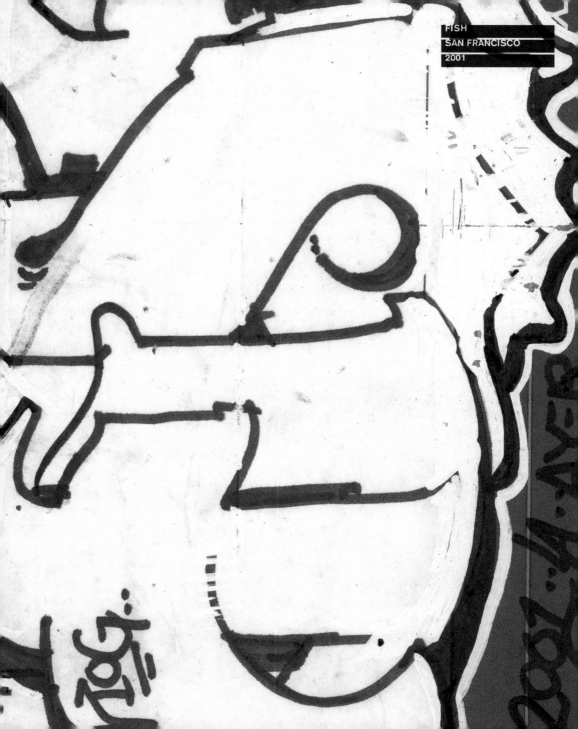

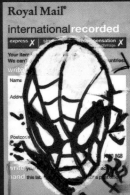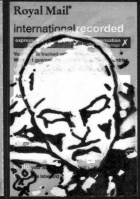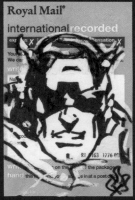

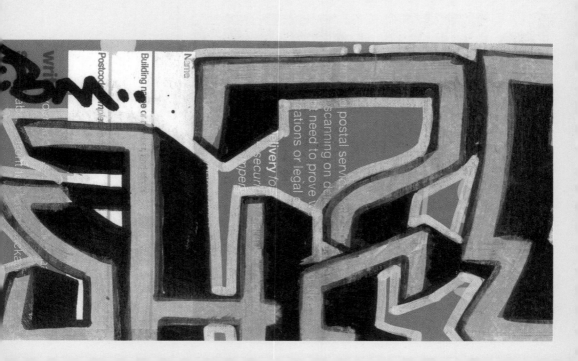

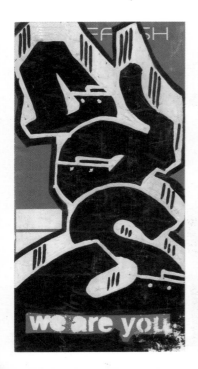
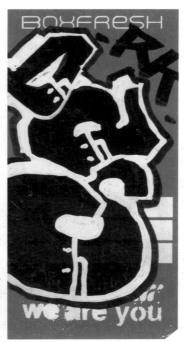

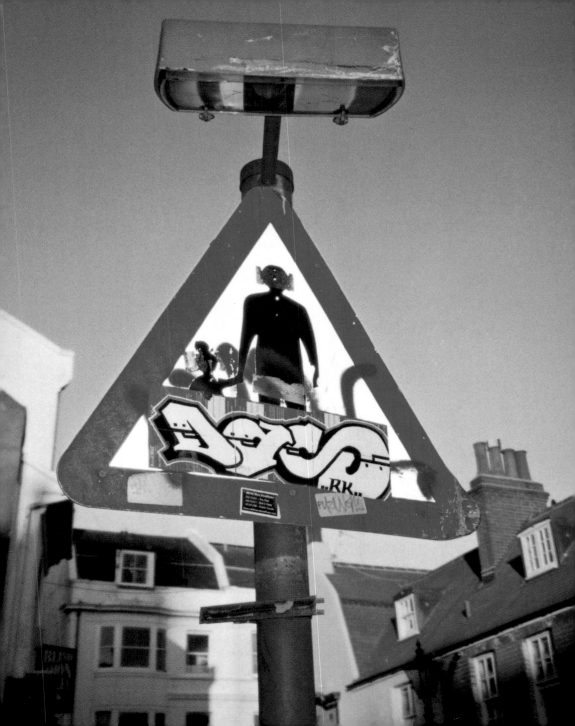

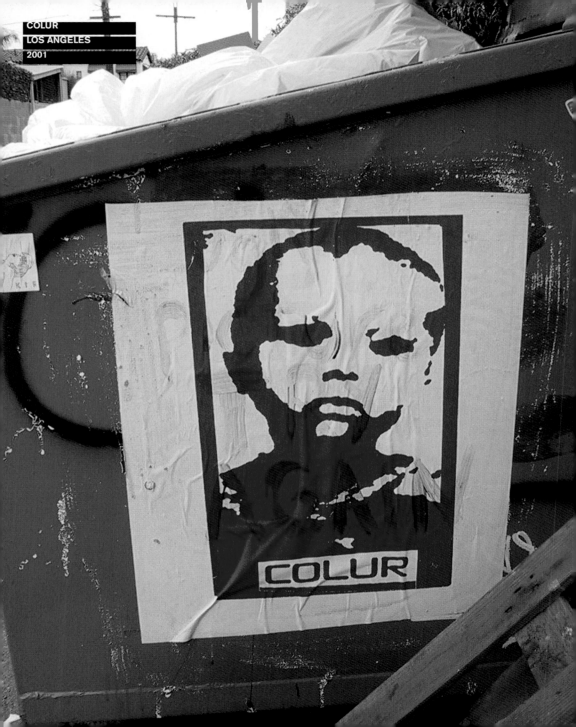

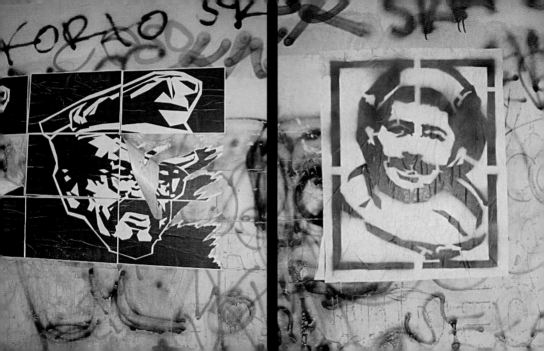

PAY HERE

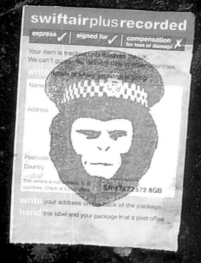

swiftair plus recorded

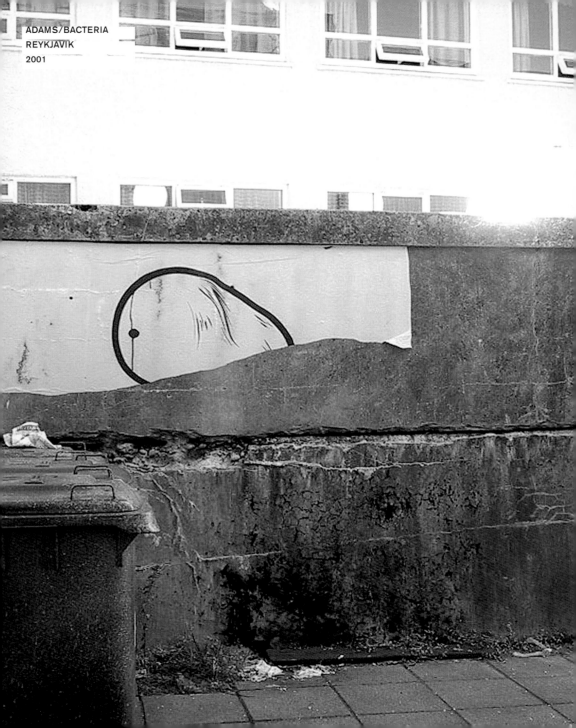

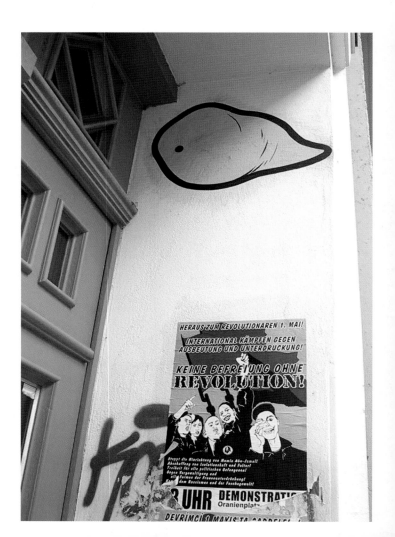

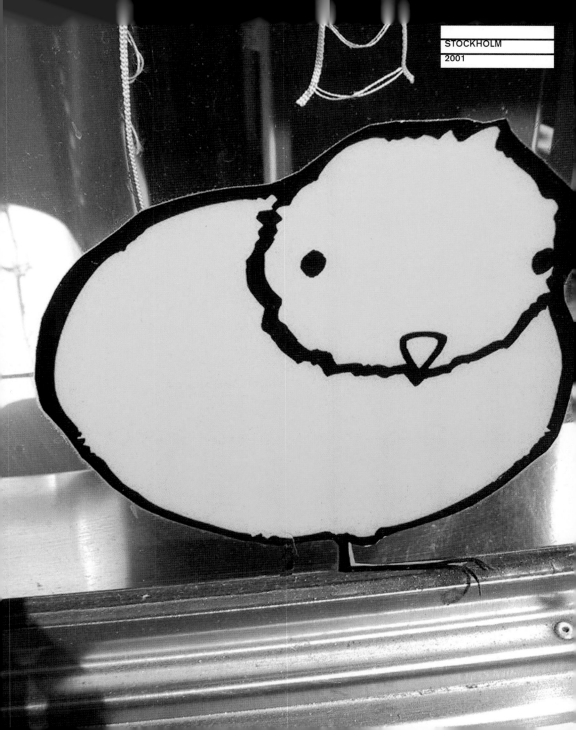

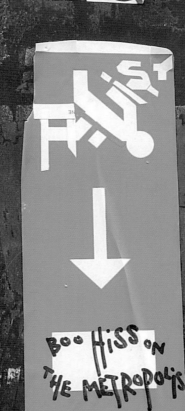

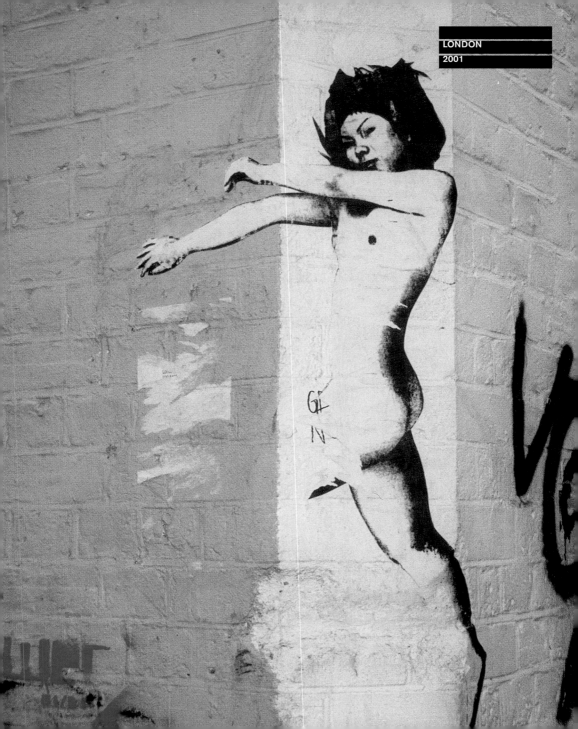

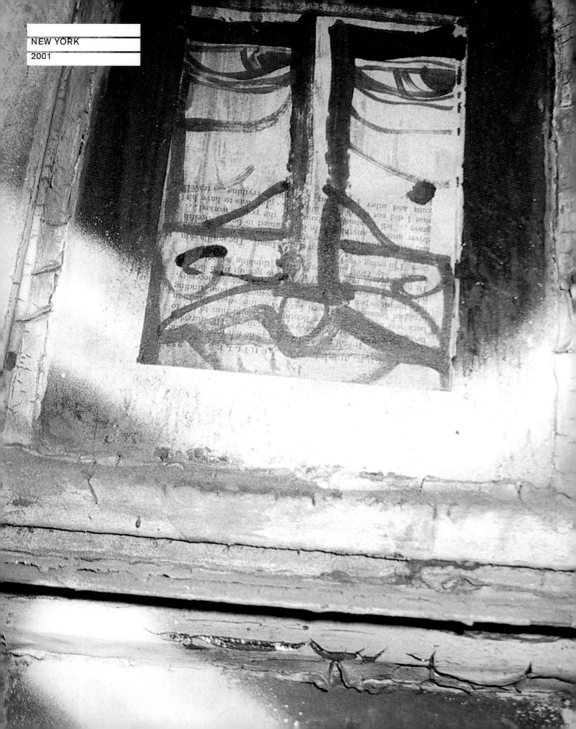

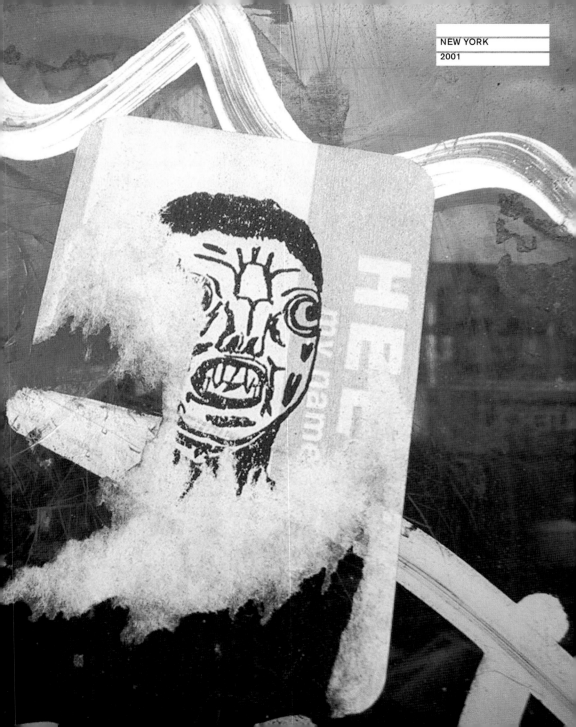

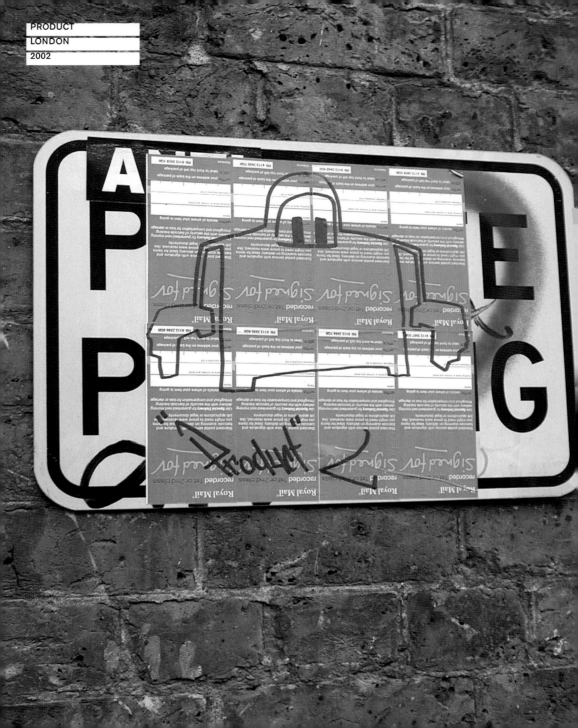

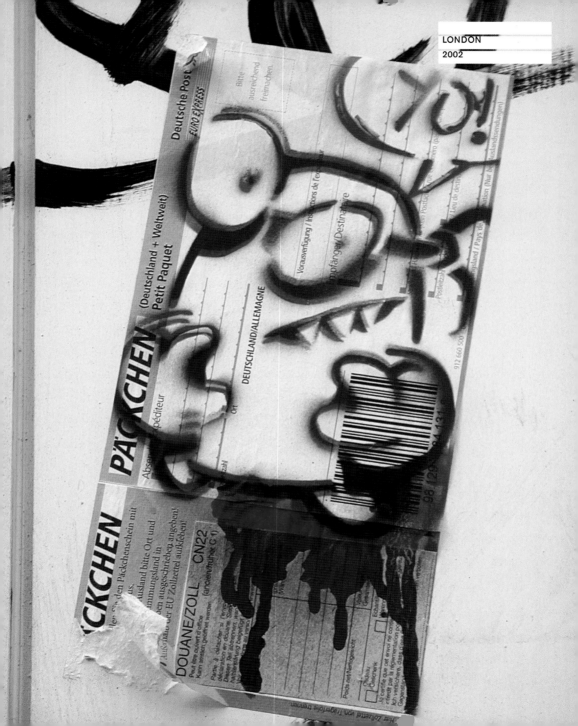

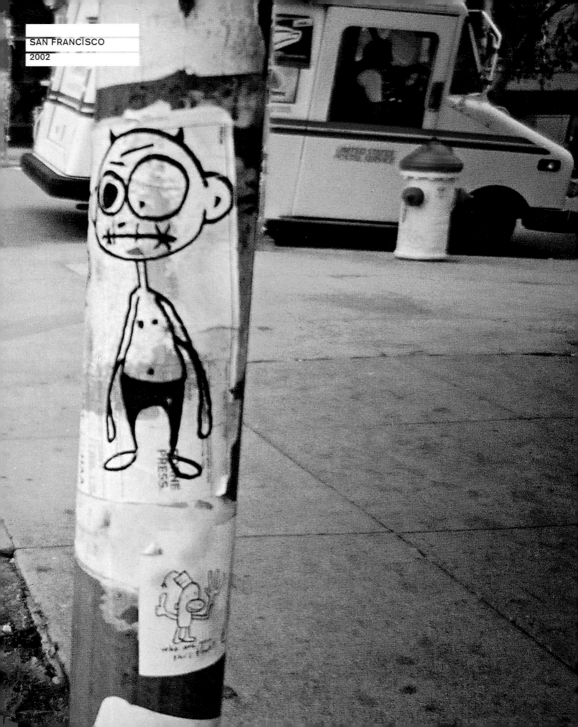

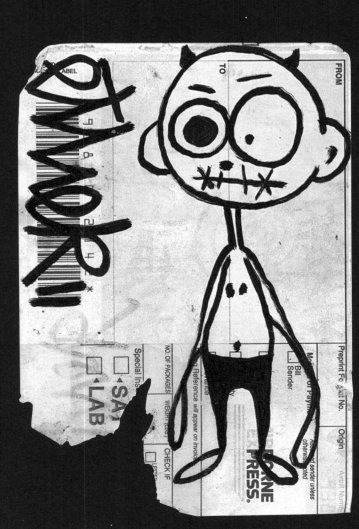

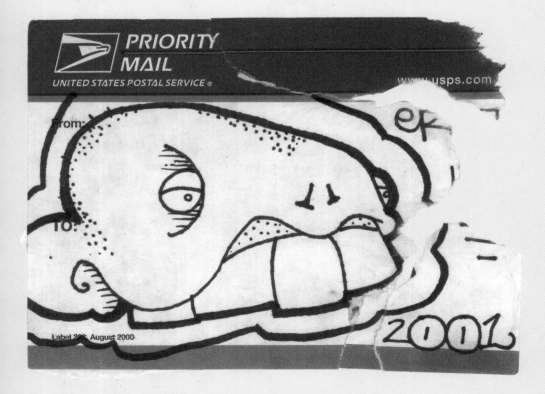

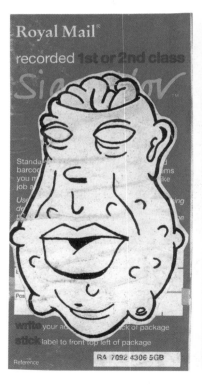

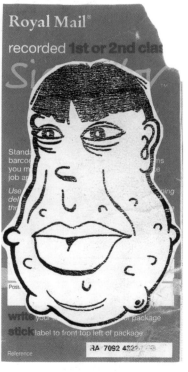

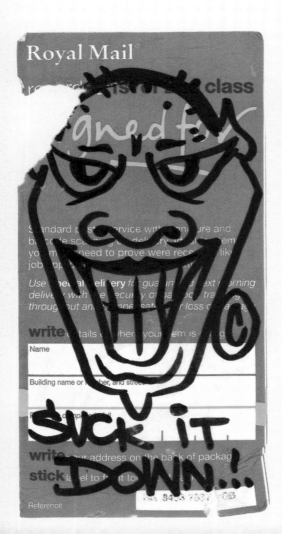

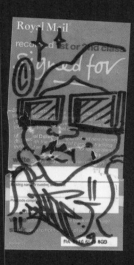

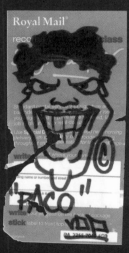

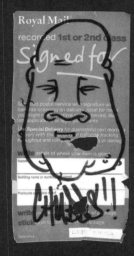

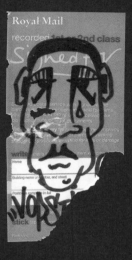

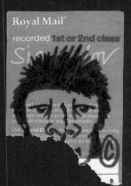

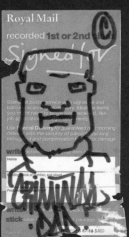

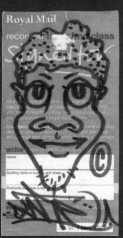

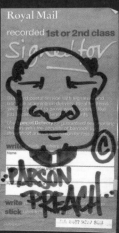

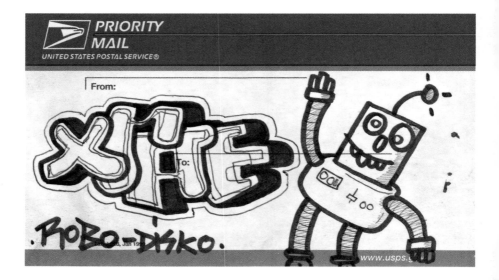

NO.

○欄の記入は担当ドライバーにおまかせ下さい。

個数

御

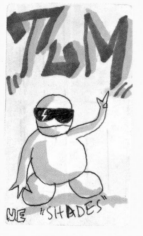

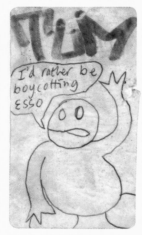

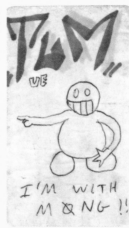

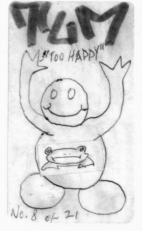

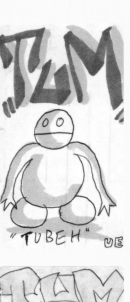

"TUBEH" UE

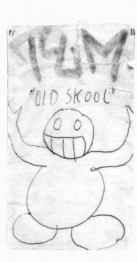

"OLD SKOOL"

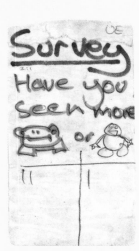

Survey
Have you
seen more
[] or []

www.Kill Frog.com

2 of 11
"SEX 4 MAMA"

8 of 11
"HOROSCOPES"

THE ORIGINAL SMILE
No. 1 of 21

WUB WUB!
^_^ O_o

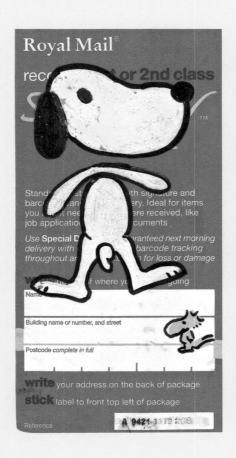

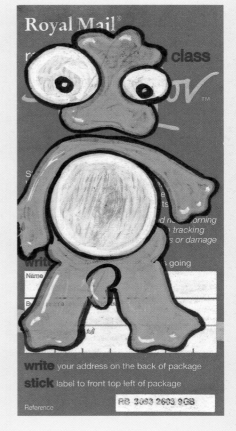

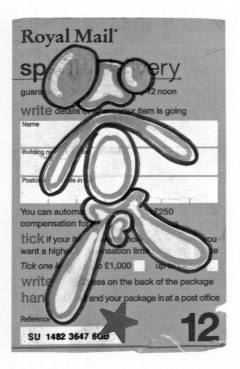

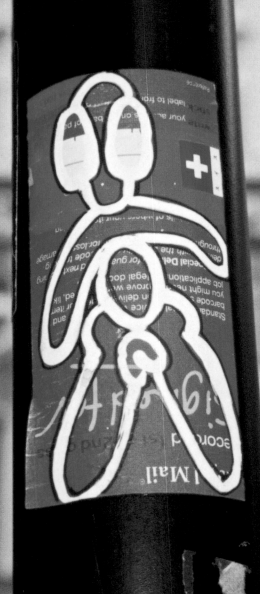

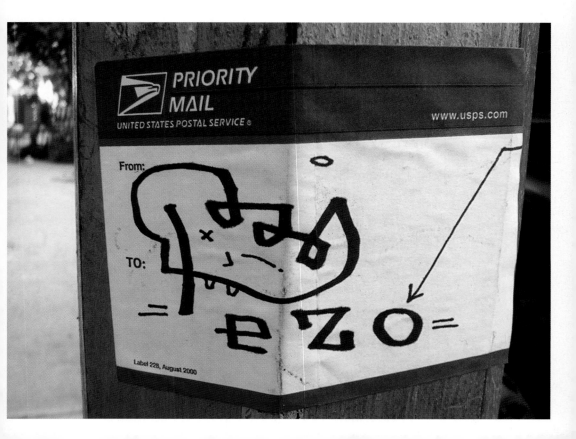

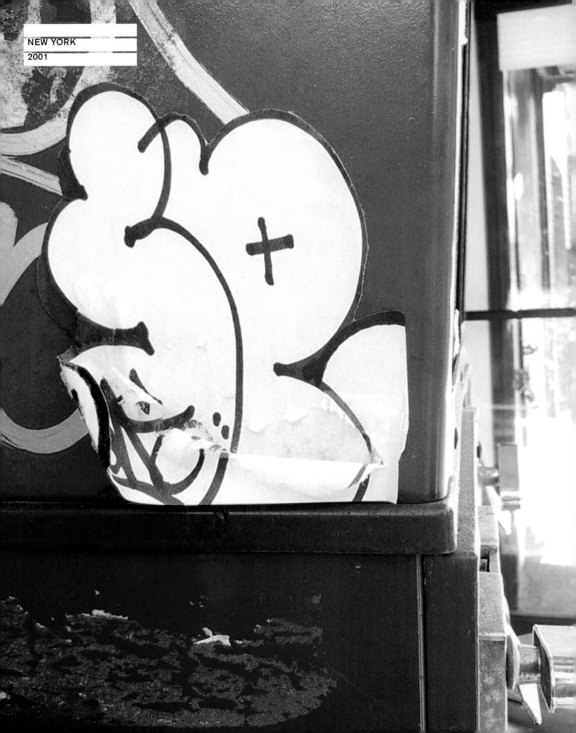

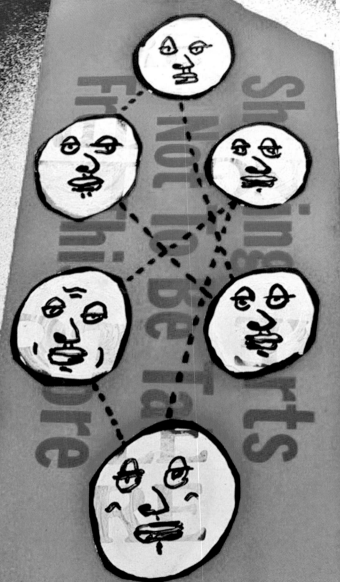

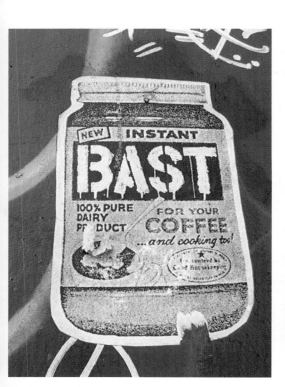
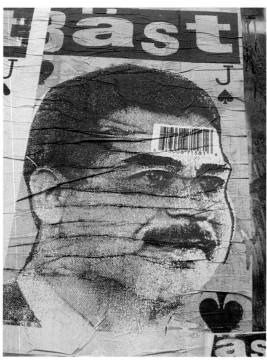

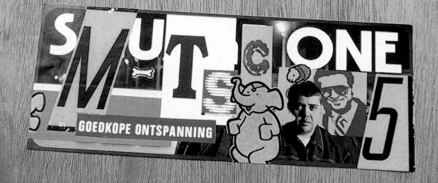

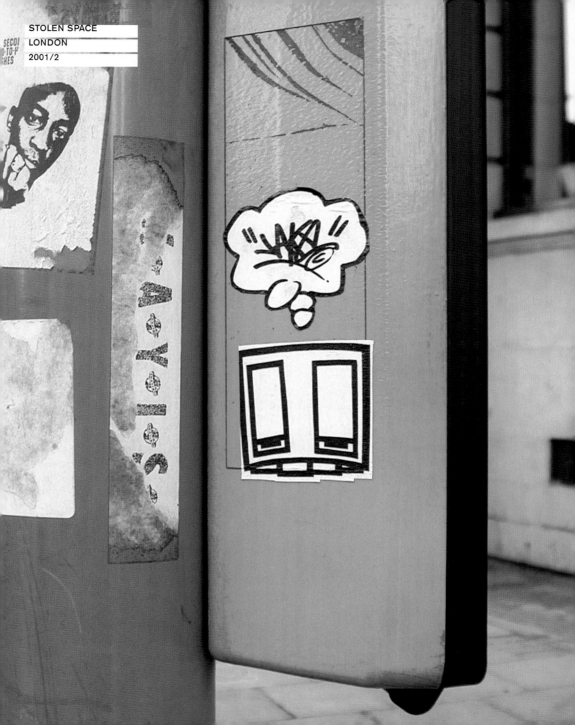

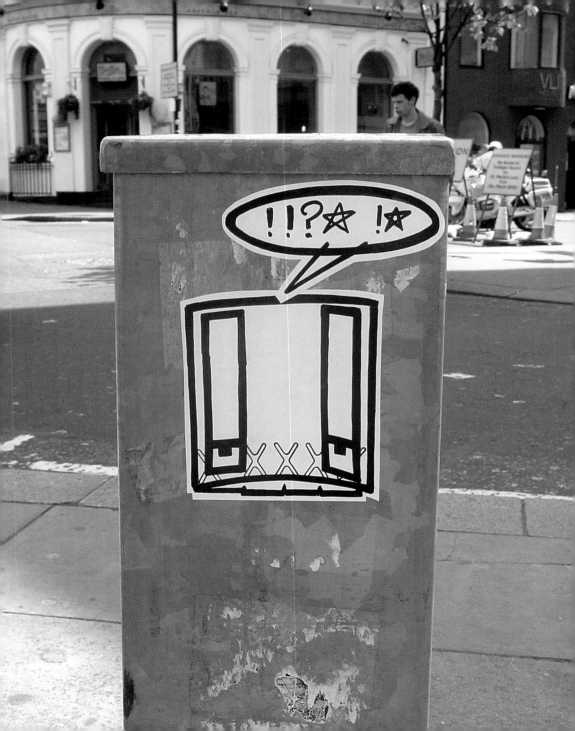

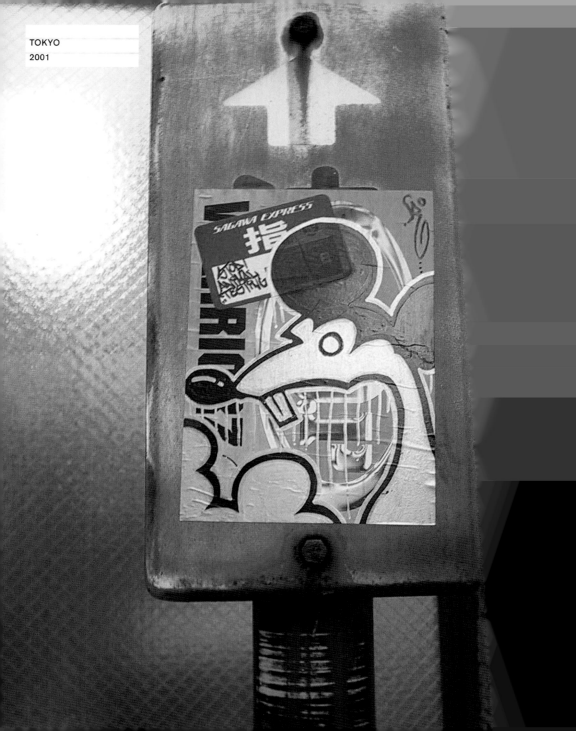

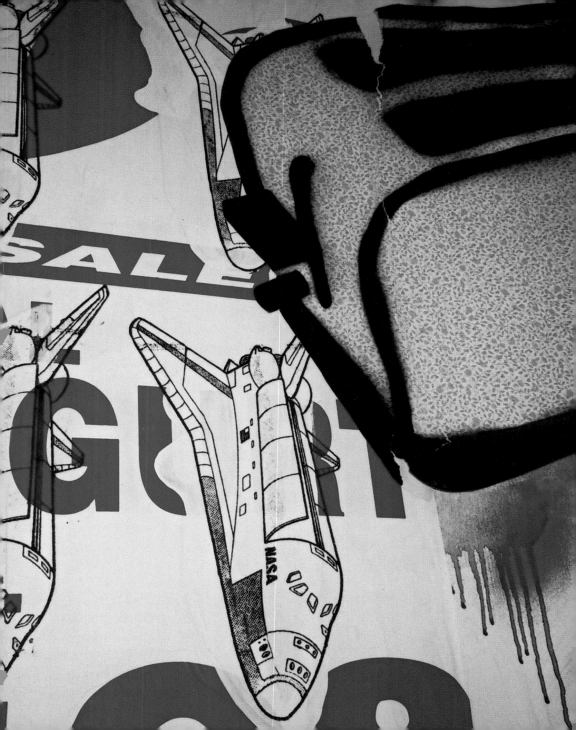

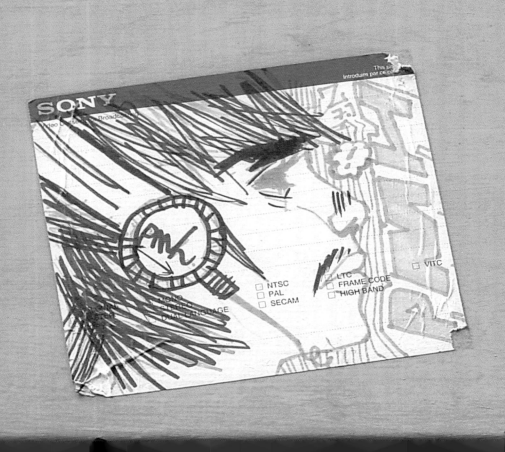

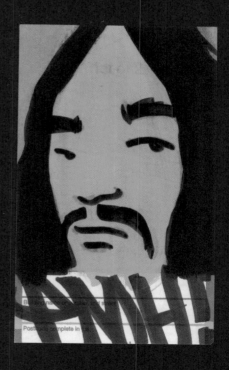

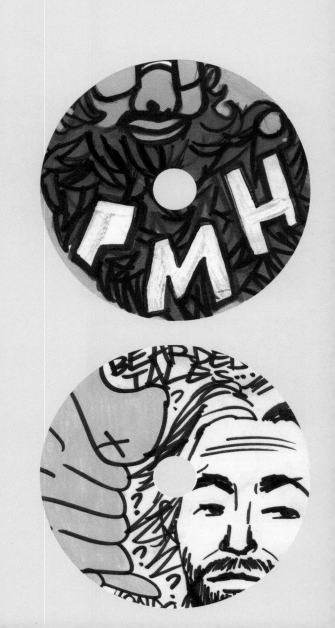

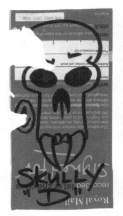 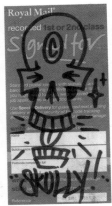 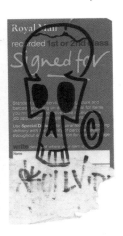

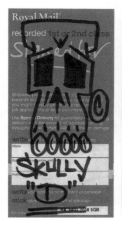 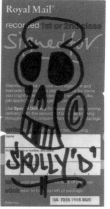

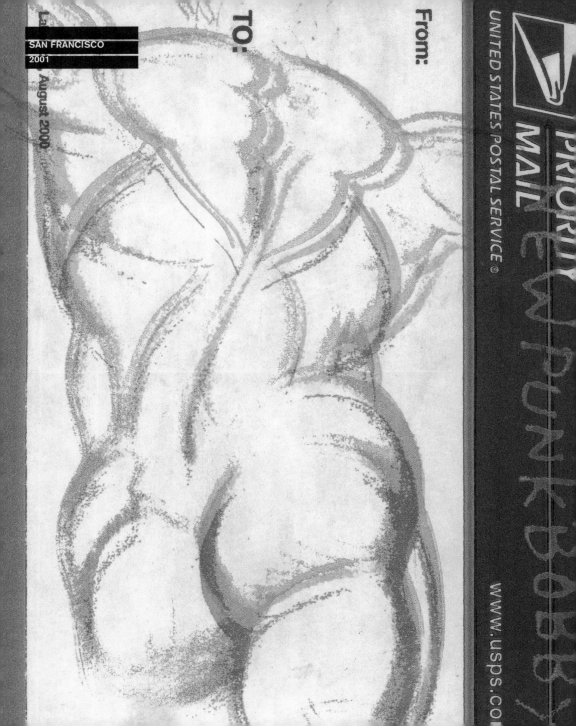

From:

TO:

From:

To:

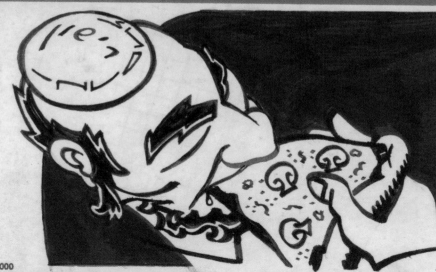

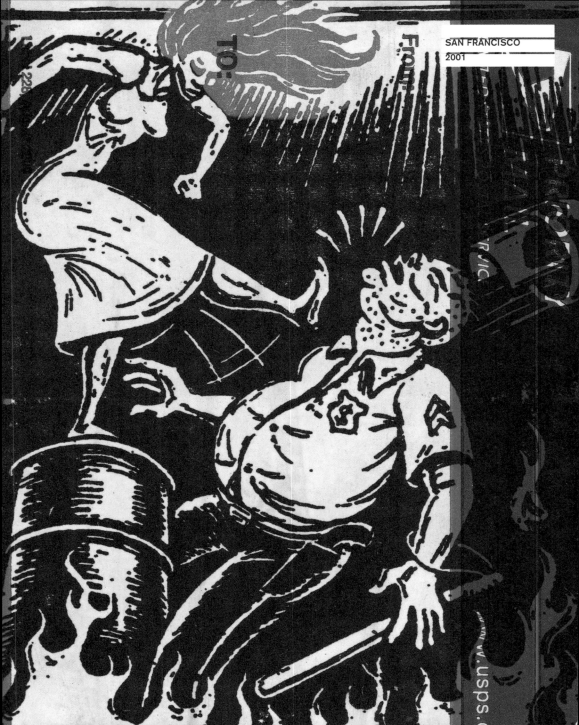

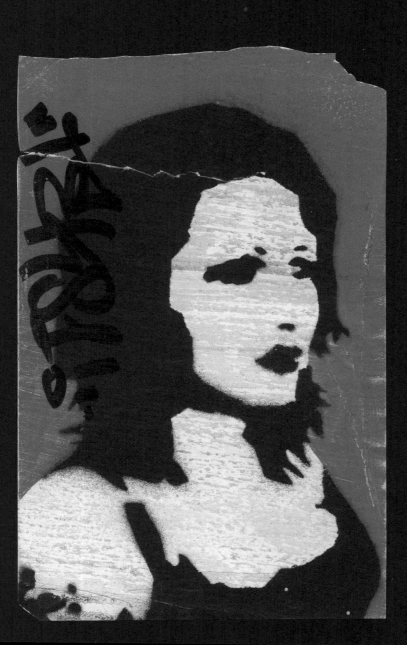

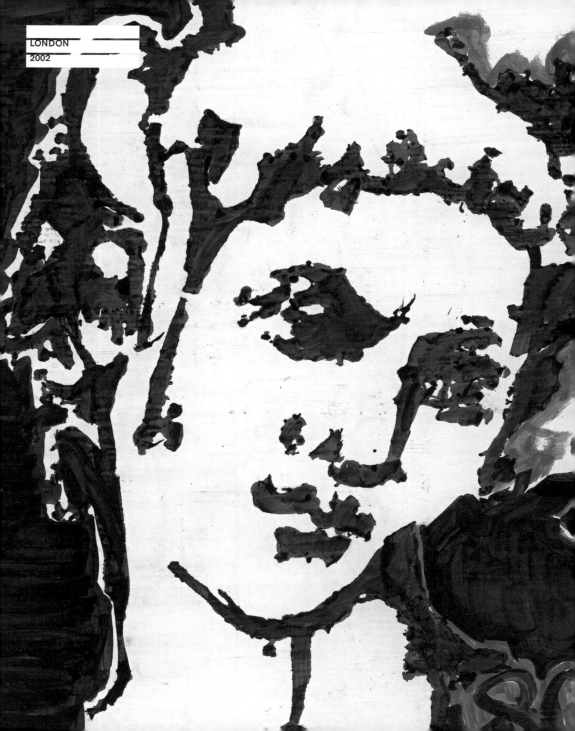

A VISIT
FROM
the outer
FAIRY10

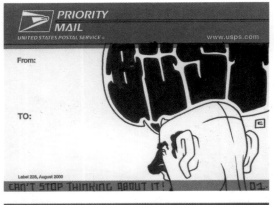

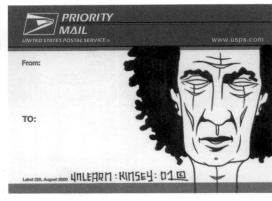

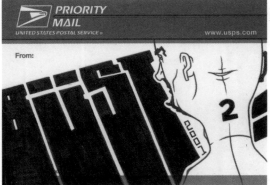

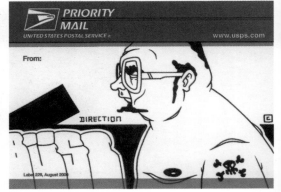

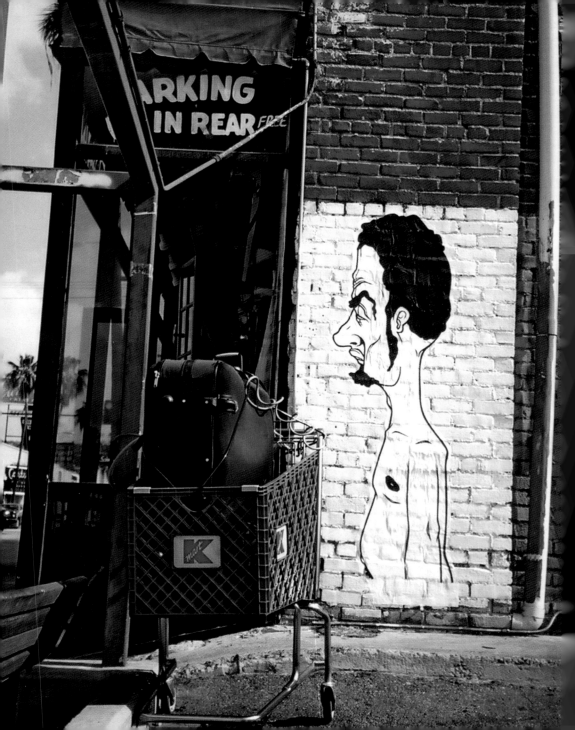

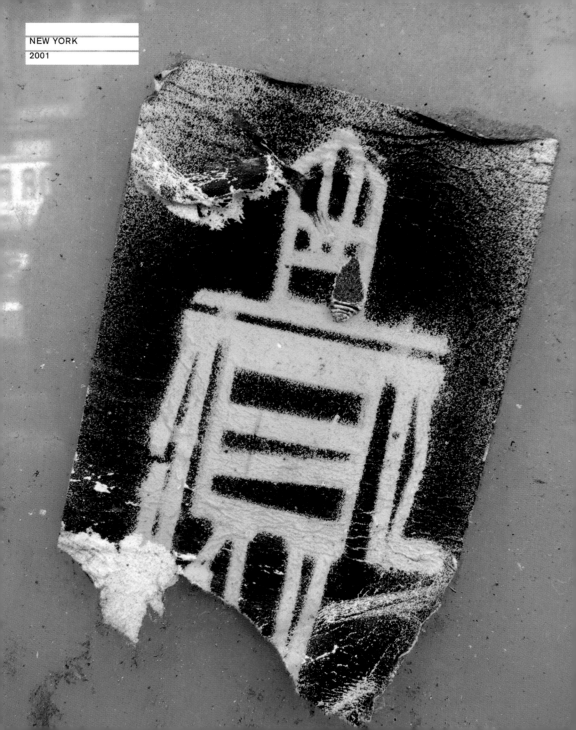

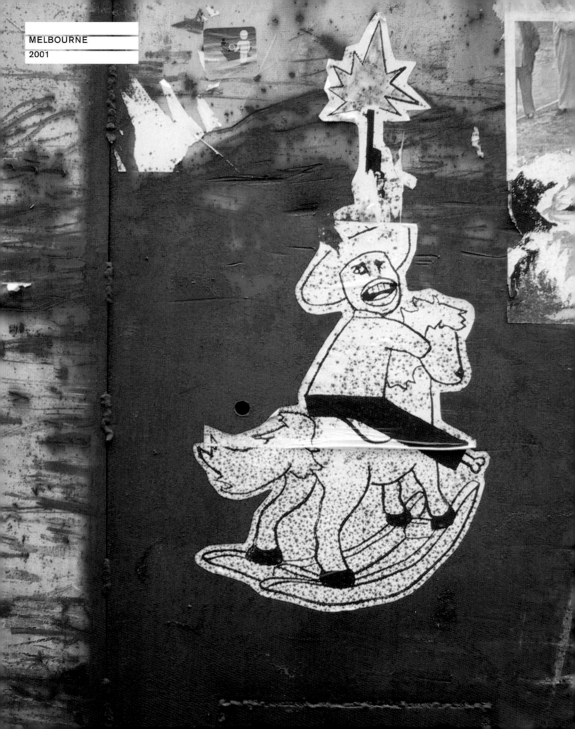

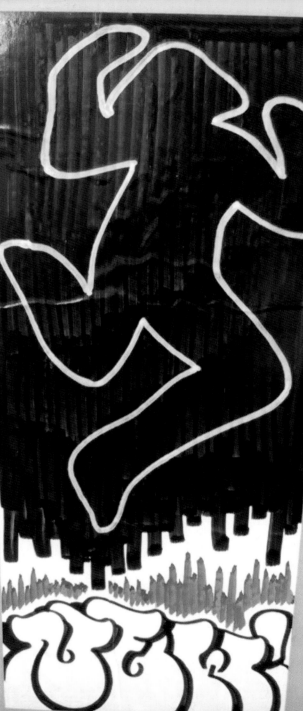

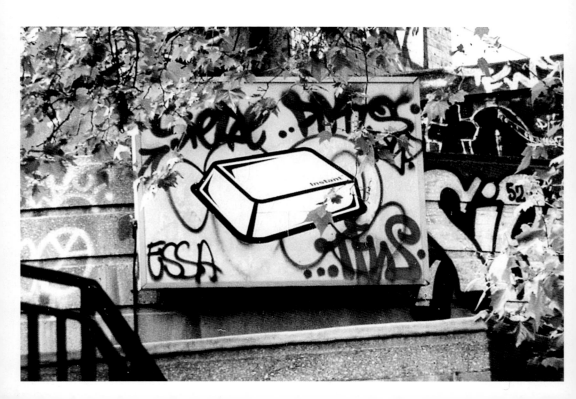

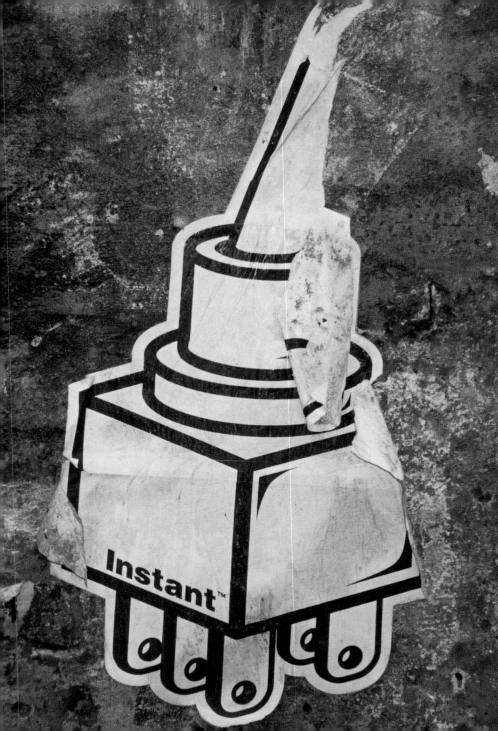

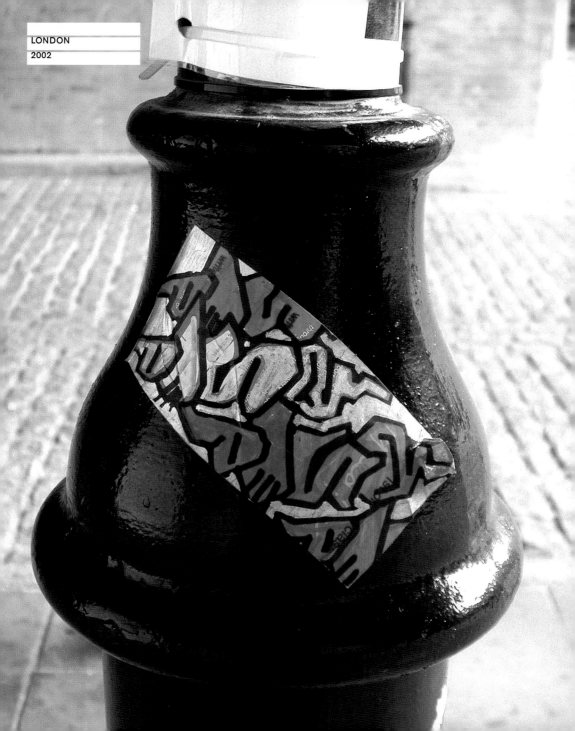

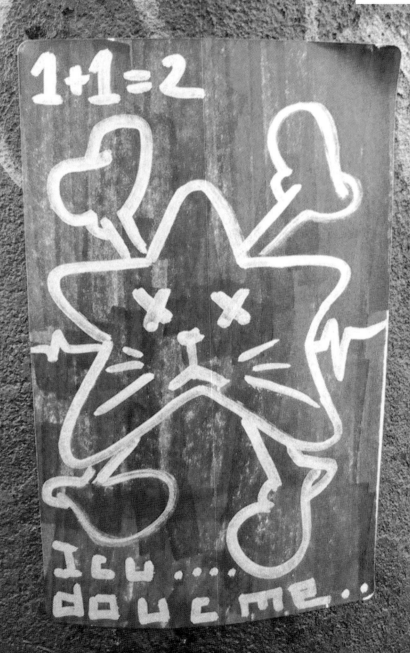

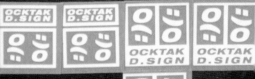
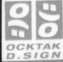
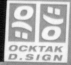
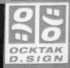

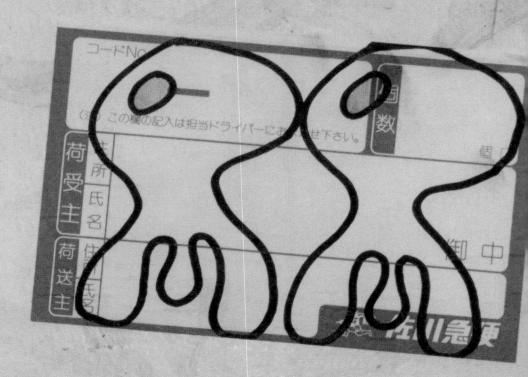

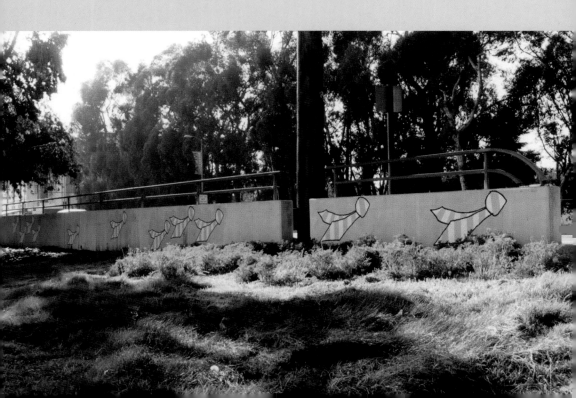

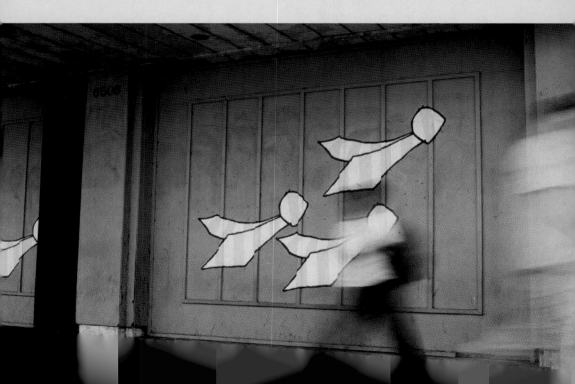

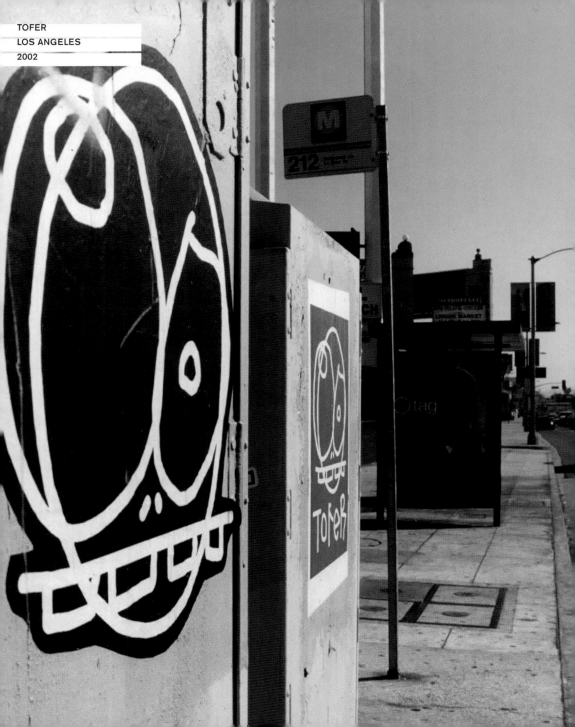

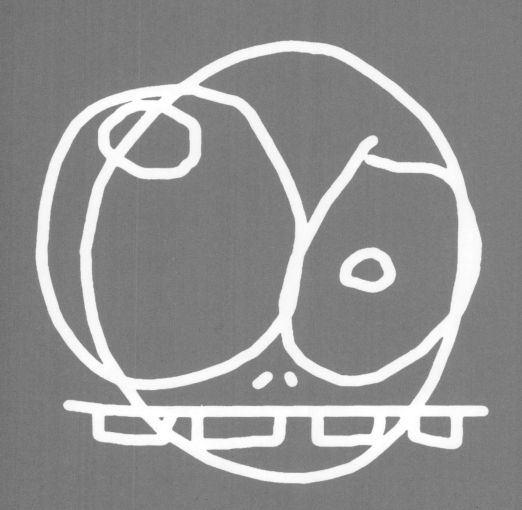

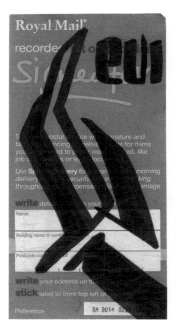

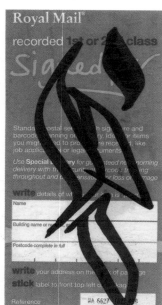

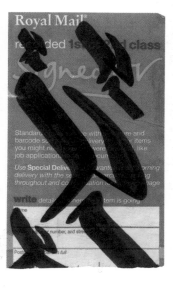

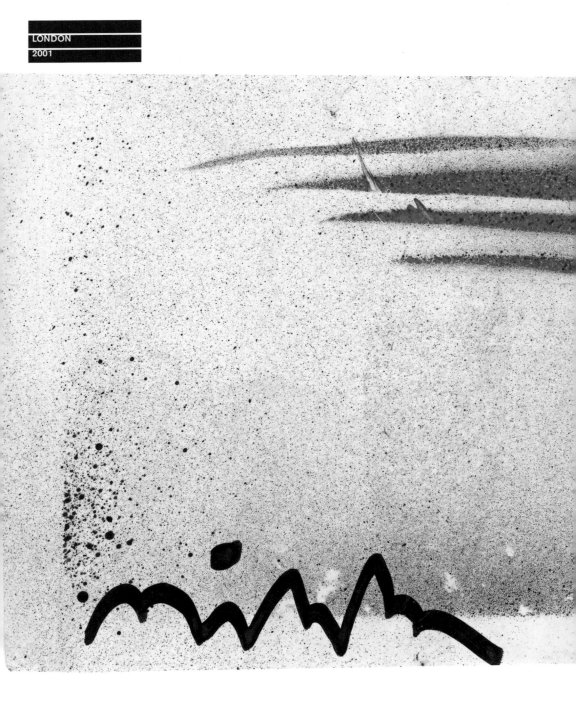

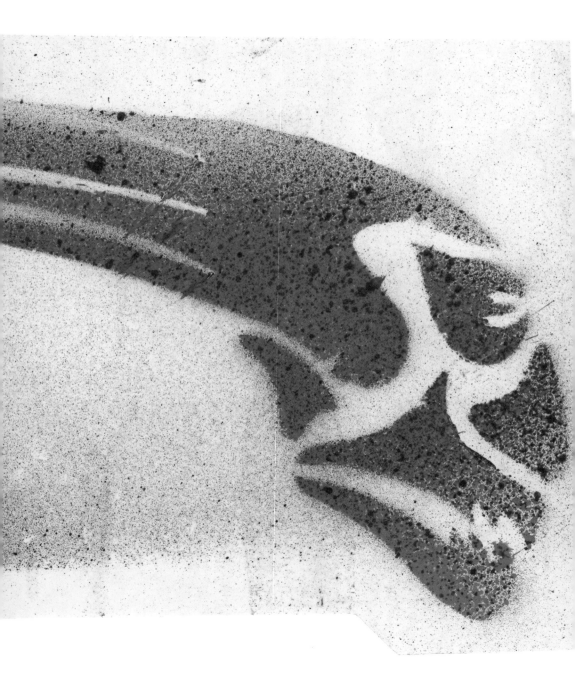

MAGIC™
BEAN
SERIES

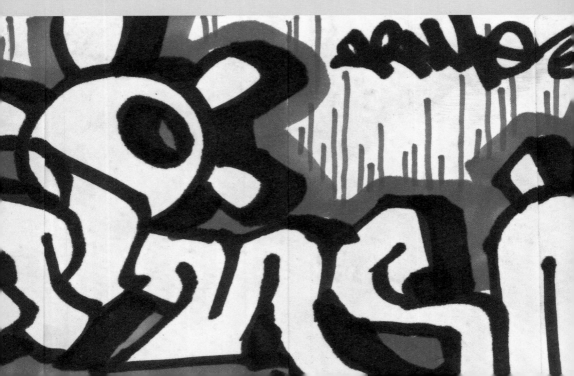

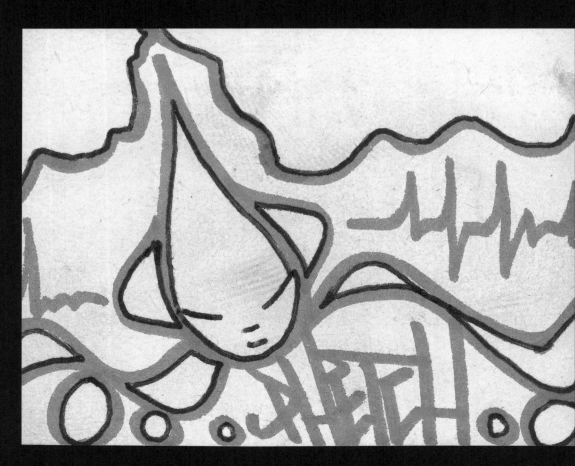

Royal Mail
specialdelivery.

guaranteed next working day by 12 noon

write details of whe____ ___ going

write

Name

12

___ and you
___ tra price

500

____ckage

___ post office

You c___
com___

Tic___

Tick o___
wa___ g___

writ___
hand this label an___

SU 1482 3634 3GB

Royal Mail

special delivery

guaranteed n

write de

Name

Building name or n

Postcode comp

You can a

compens

tick

want a

Tick o

write

hand

Reference

ndon

going

ns

50 and you

extra price

£2,500

ne package

at a post office

SU 1482 3606 5GB

12

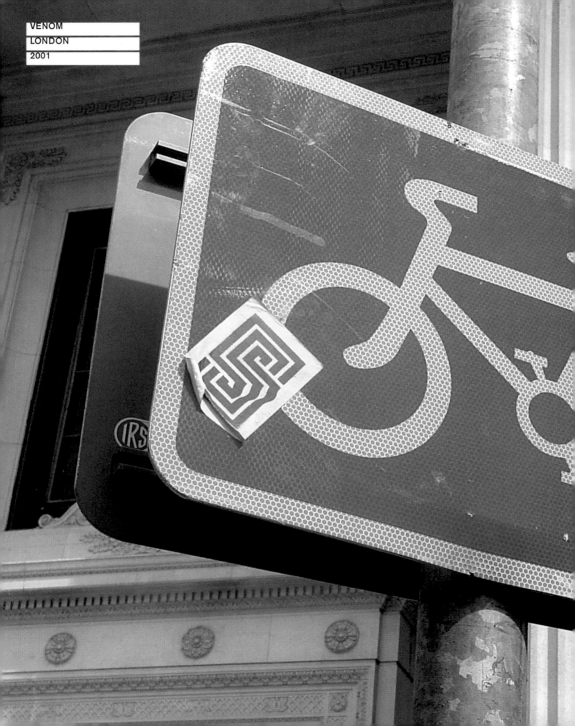

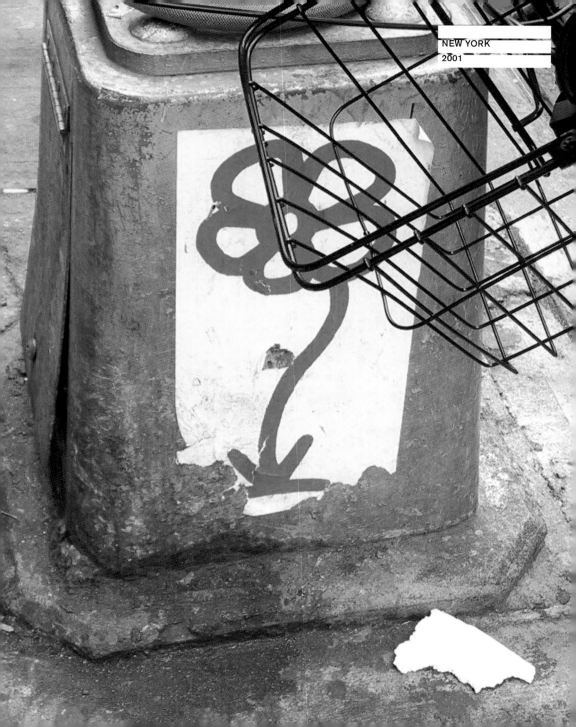

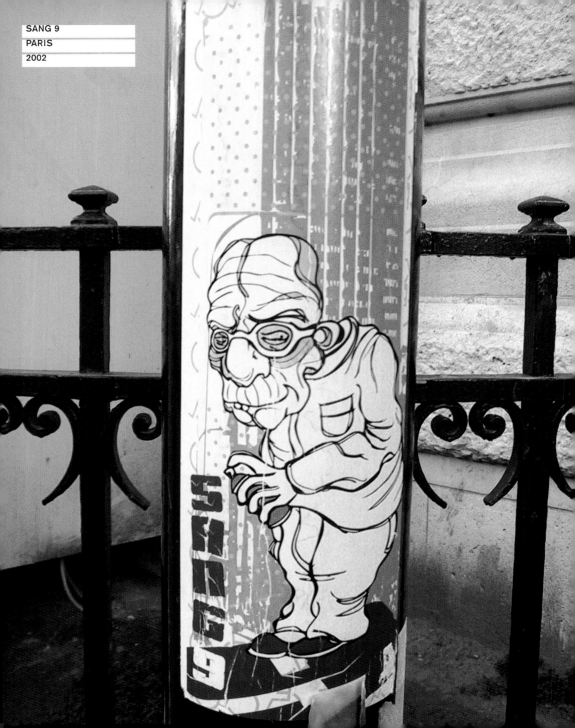

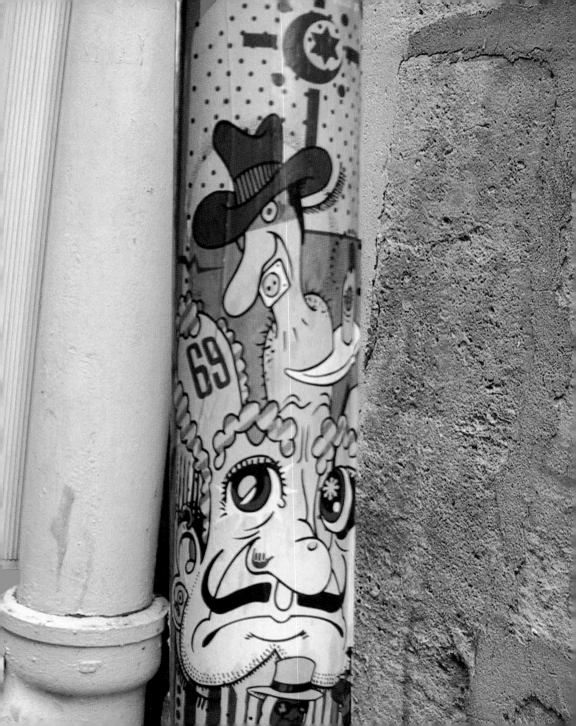

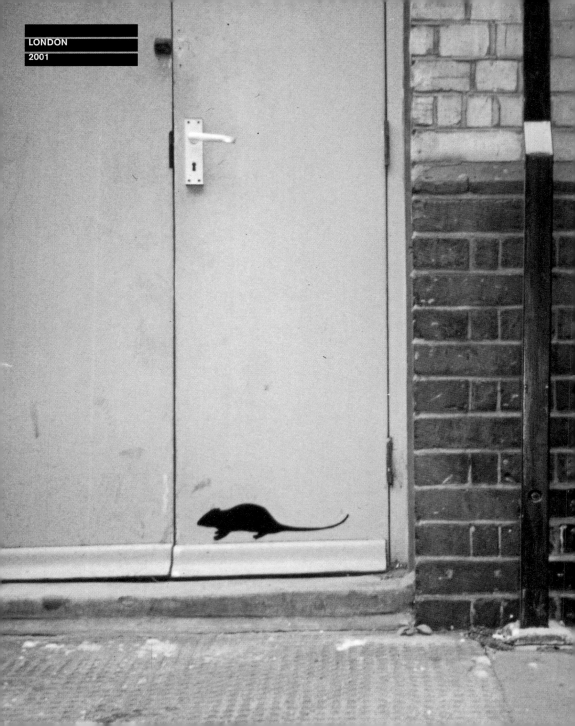

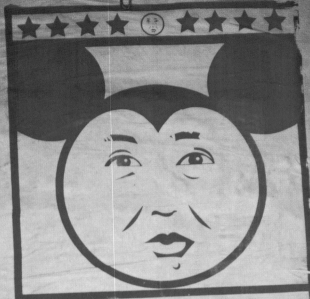

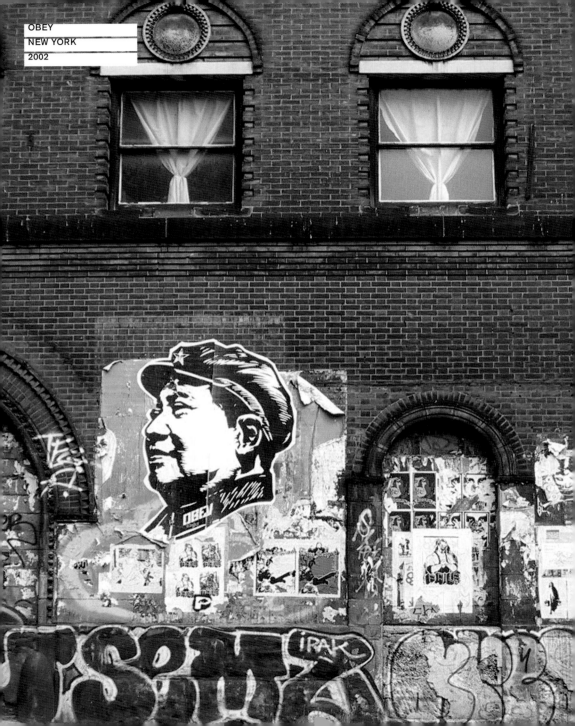

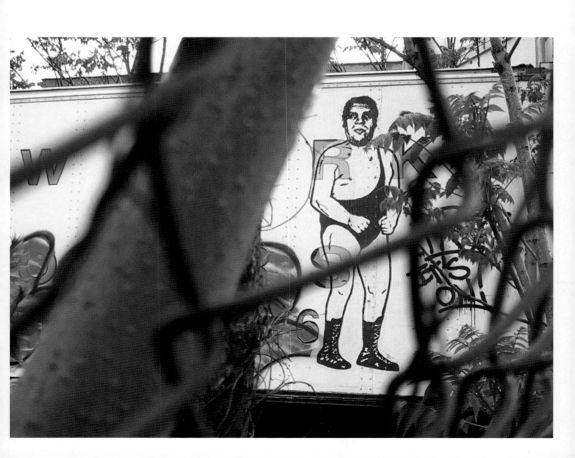

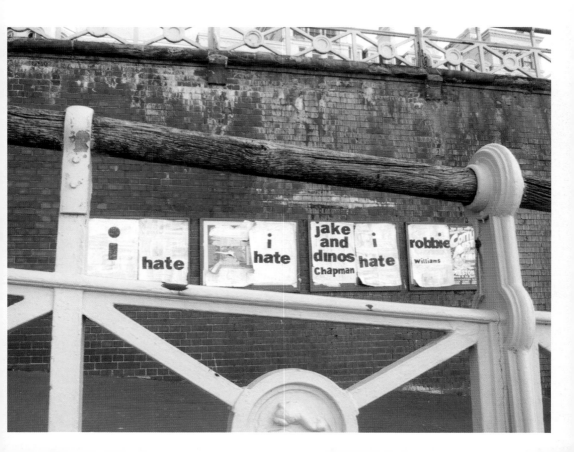

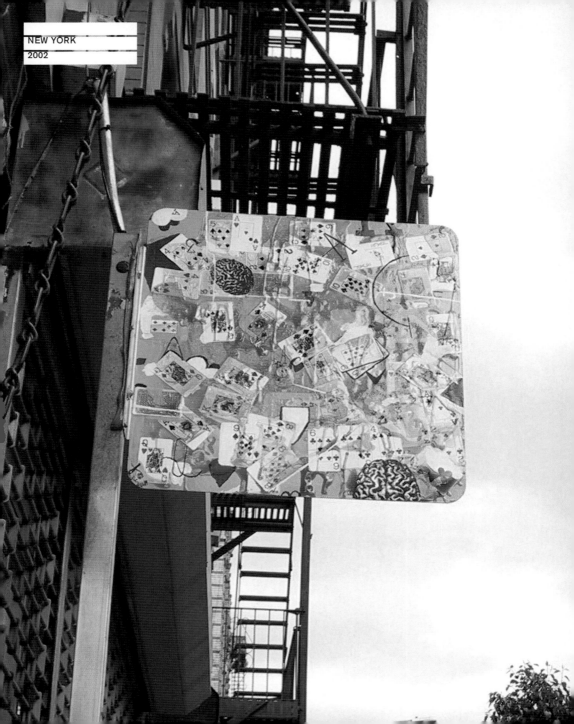

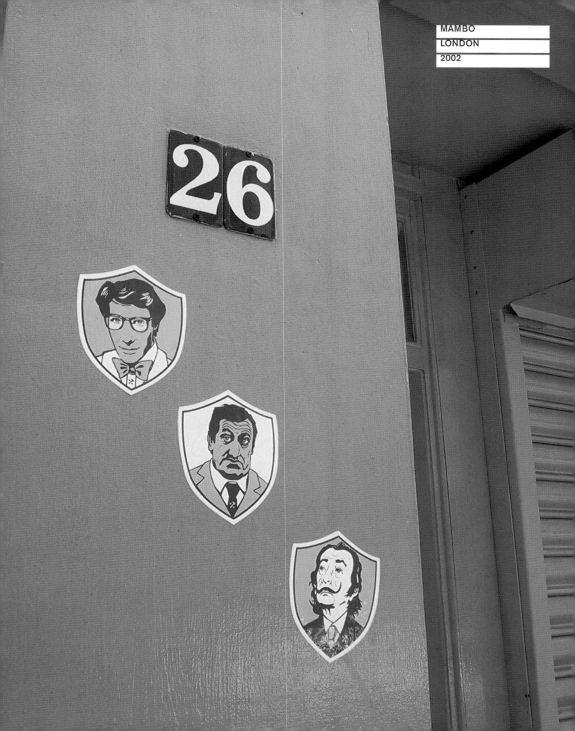

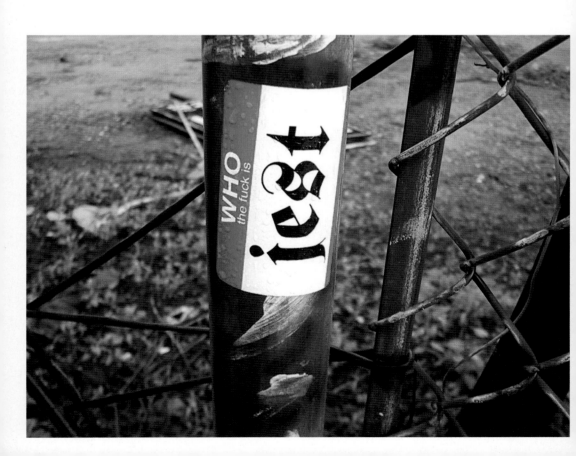

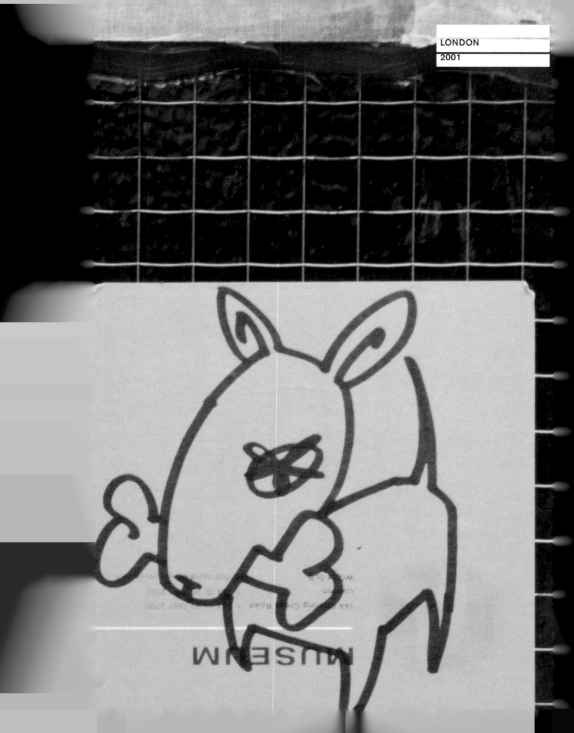

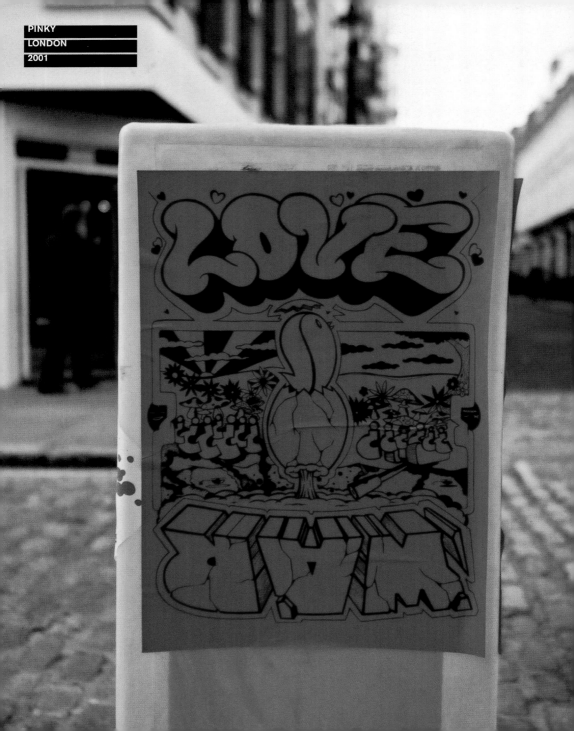

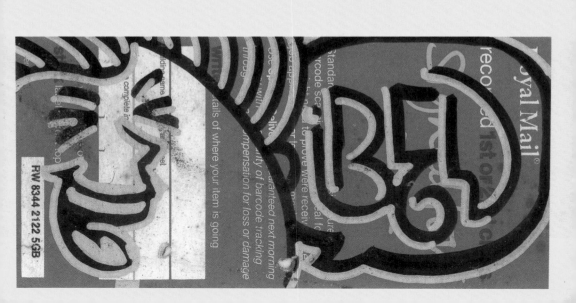

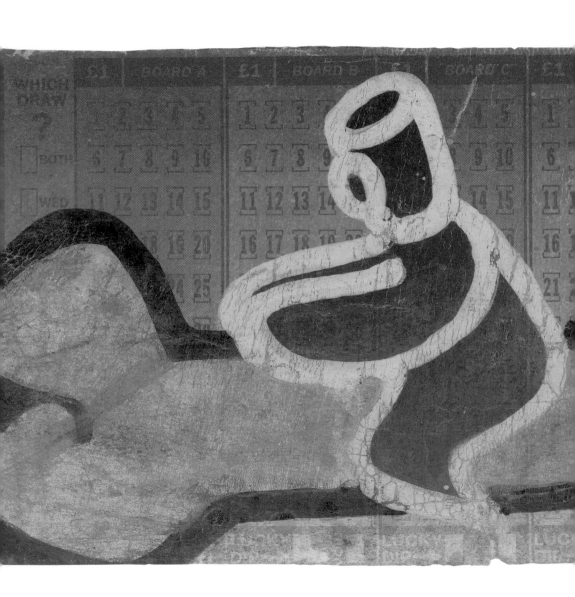

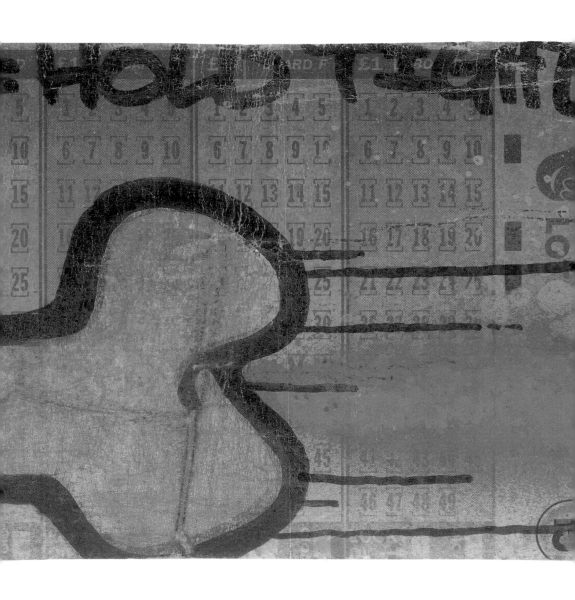

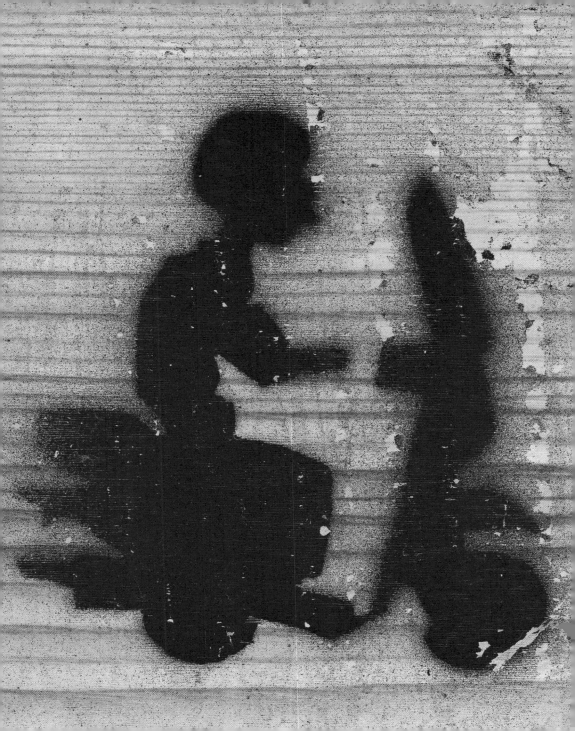

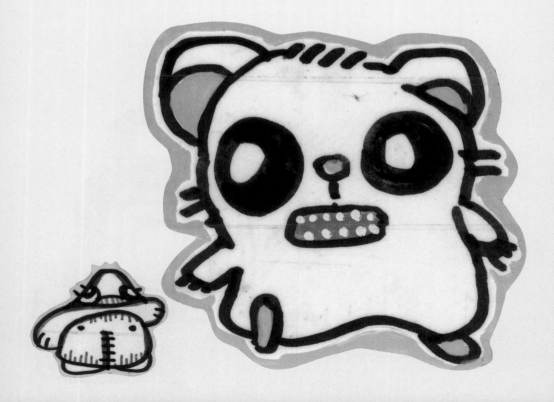

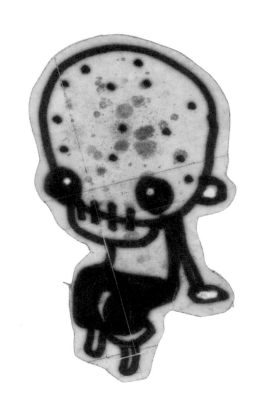

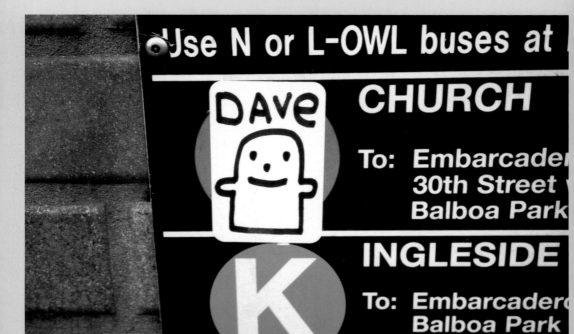

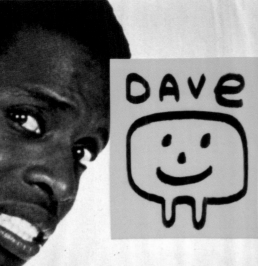

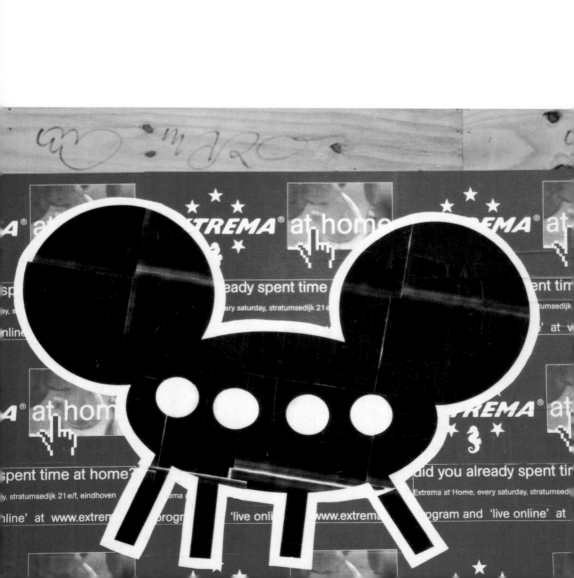

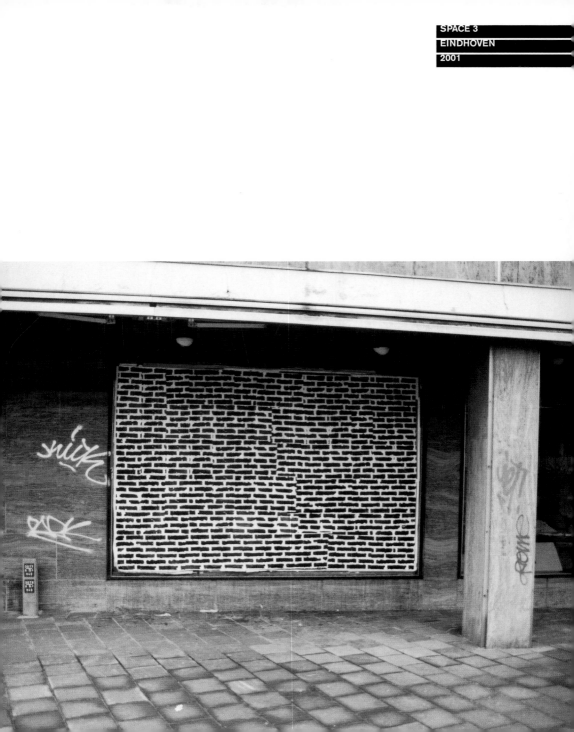

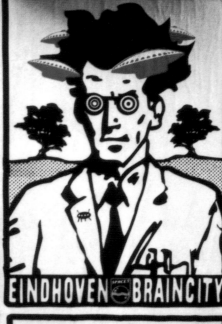

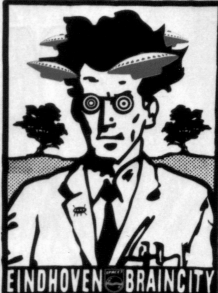

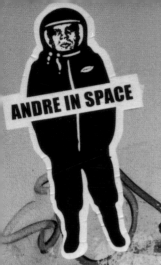

ANDRE IN SPACE

LEVENSGEVAARLIJK

HOGE SPANNING

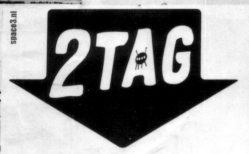

space3.nl

space3.nl

2TAG

2TAG

space3.nl

SPA CE3

space3.nl

SPA CE3

2TAG

2TAG

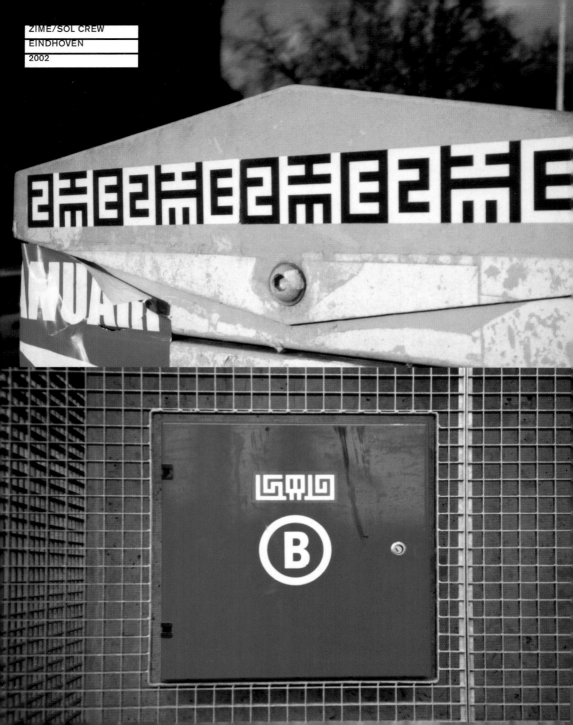

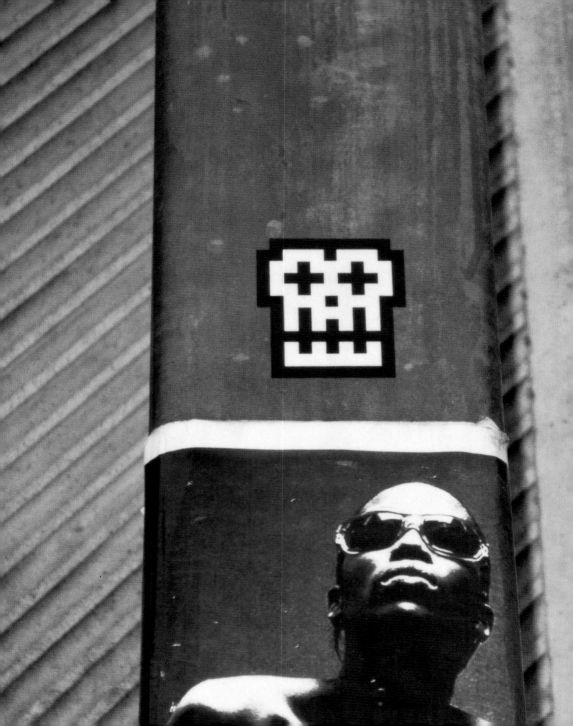

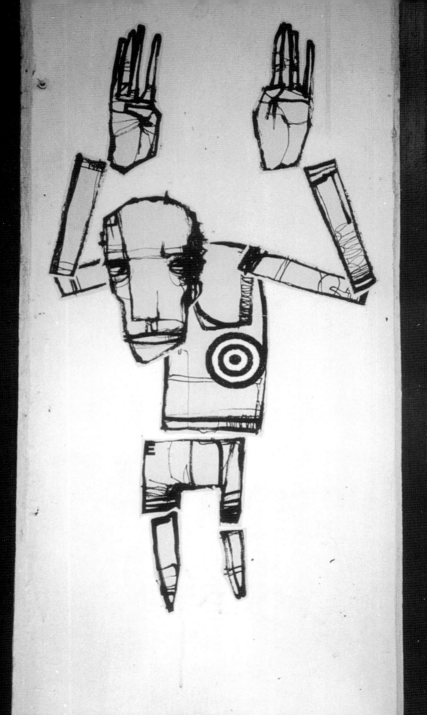

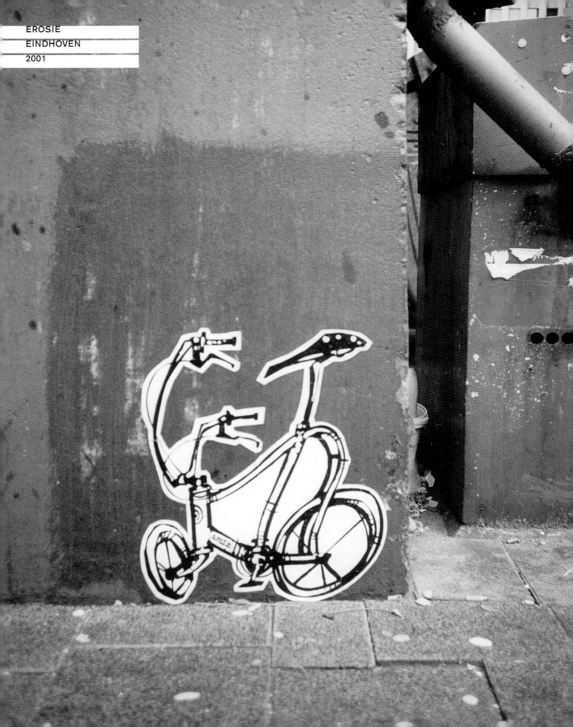

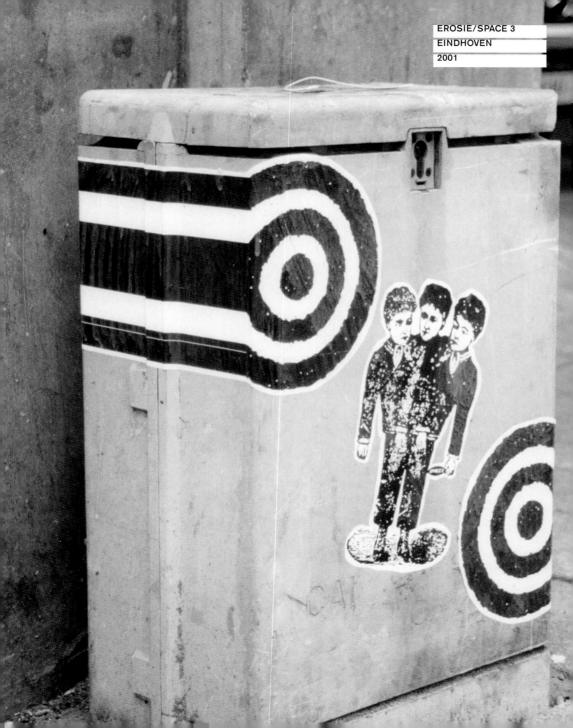

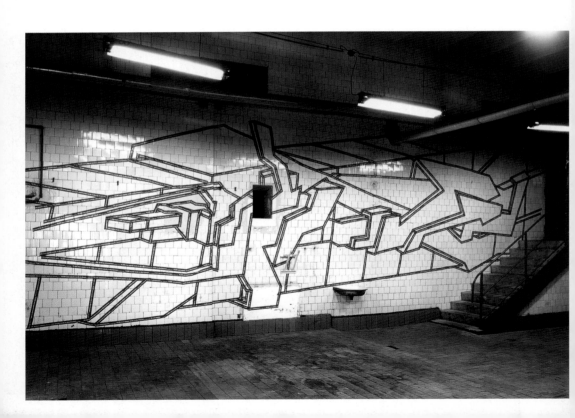

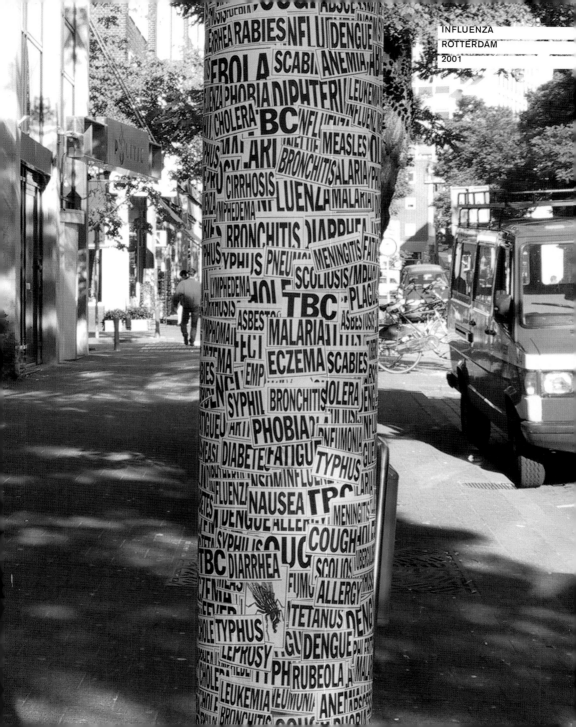

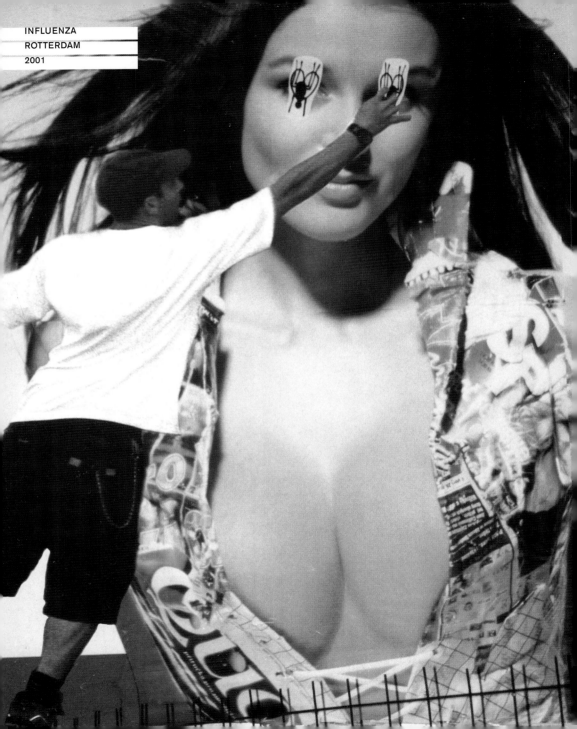